AN IRRESISTIBLE HISTORY OF

ALABAMA
BARBECUE

From **WOOD PIT**
to **WHITE SAUCE**

To khalel —
 keep up the great work!
Enjoy! *Mark Johnson*

MARK A. JOHNSON

AMERICAN PALATE

Published by American Palate
A Division of The History Press
Charleston, SC
www.historypress.net

First published 2017

Manufactured in the United States

ISBN 9781467137027

Library of Congress Control Number: 2017938334

I dedicate this book to my wife, Kate, who introduced me to Alabama white sauce and supported me in the publication of this book.

CONTENTS

ACKNOWLEDGEMENTS

I am thankful for numerous people who have helped me with this book. I am particularly grateful to the Southern Foodways Alliance, especially John T. Edge, and the Alabama Tourism Department. They provided me the opportunity to study Alabama barbecue. I could not have done this project without the oral histories conducted and archived by the Southern Foodways Alliance.

I owe a debt of gratitude to Joshua Rothman. With the grant funded by the Southern Foodways Alliance, he hired me to produce the now-entitled essay "Pork Ribs and Politics: The Origins of Alabama Barbecue." I would never have approached barbecue from a historical perspective if not for his choosing me. I could never have completed the project without his assistance and encouragement. In the process of writing the article, I received help from many people, especially at the University of Alabama, including Dana Alsen and Megan Bever.

In the process of turning the original article into a book-length project, I encountered many helpful people and their scholarship. I benefited from the work of many scholars, especially Angela Cooley, who helped me take my first steps into food history. I owe much of my initial understanding of the subject of barbecue to the work of historians Robert F. Moss and Valerie Pope Burnes. In my own work, I have attempted to live up to the standards set by these scholars. I have blended their work with my own research to trace major historical developments with specific attention to Alabama's unique people and places.

ACKNOWLEDGEMENTS

During the research phase of producing this book, I accumulated many debts. I would like to thank the many restaurateurs who spent time sharing their stories and feeding me. I hope I have done justice to your hard work. I would also like to thank the staff at the Center for the Study of the Black Belt at the University of West Alabama. They helped me find archival material related to this project.

Finally, I am grateful to the support of family and friends. First, I would like to thank my parents, who taught me to love history and how to work hard. Next, I would like to thank Pat and Melissa, who gave me the nickname "Dr. BBQ." I could not have completed this project without the love and support of my wife, Kate, to whom I dedicate this book.

INTRODUCTION

Alabama barbecue serves as a source of state pride. Nationally, Memphis, North Carolina, St. Louis and Texas get the publicity. In restaurants and backyards across the state, Alabamians boast about the state's barbecue. They have put their own barbecue up against the food from any of these other places. In these contests, they have had their fair share of victories.

Within the state, however, Alabamians do not even agree about how to define Alabama barbecue. In the Tennessee River Valley, barbecue means chicken with white sauce. In Birmingham, barbecue entails pork on a sandwich with a tomato-based sauce and a couple pickles. In Tuscaloosa, barbecue consists of ribs basted with a spicy vinegar-based sauce. These generalizations still do not adequately describe Alabama barbecue. In the Tennessee River Valley, for example, customers can also find mustard-based hotslaw at many of the local restaurants, especially in the Shoals.

If barbecue does not have a defining ingredient or flavor profile, it does have a unique story. In Alabama, barbecue transcends race, class and generational boundaries and relies on a multi-racial and multi-ethnic restaurant-based scene emphasizing open pits and hickory wood.

From the beginning, Alabama barbecue did not necessarily have these characteristics. Instead, they developed over time. These defining elements of Alabama barbecue have evolved over the past four hundred years, with roots in the Columbian Exchange, slavery and emancipation, Jim Crow and civil rights and the rise of the restaurant industry. In each phase of development,

Alabama barbecue attained some of its present-day characteristics. This is the story I tell in this book.

Throughout the book, I weave many stories together. On the national level, historic events shaped how people produced and consumed food, including barbecue. In *Barbecue: The History of an American Institution*, historian Robert F. Moss explains these developments and their affect on barbecue across the nation. I could not have produced this history of Alabama barbecue without Moss's path-breaking work. In this book, I have told a story about how national and local events played out in Alabama, affected the restaurant industry and, therefore, influenced barbecue in the state.

In this book, I refer to barbecue as a food, a cooking technique and a social event. As a food, Alabama barbecue consists of many different types of meat, sauces and preparation methods. I have used the term to describe all of them.

Finally, I want to emphasize that people from numerous ethnic and racial groups made their own contributions to Alabama barbecue. In fact, present-day barbecue could not exist without the blending of techniques, recipes, ingredients and labor from Native Americans, Africans and Europeans. So the story of Alabama barbecue begins at the point of contact between these groups of people, long before Alabama, as an entity, even existed.

"A DELICIOUS FLAVOR IN NO OTHER MANNER OBTAINABLE"

The Origins of Alabama Barbecue, 1492–1800

I n the 1000s, the Norse Vikings colonized northern North America, in present-day Newfoundland. Although their settlement of L'Anse aux Meadows did not last long, Vikings continued to visit the area to fish and hunt whales. Frequently, they came ashore to process their catch but also to trade with Native Americans. In 1492, Christopher Columbus and his crew arrived in the Caribbean. In 1493, Columbus returned with a massive fleet to commence the Spanish colonization of the Caribbean.

When Europeans made landfall in the Americas, they brought with them people, plants and diseases previously unknown to the Native Americans. Likewise, the Europeans discovered things native to the Americas that Europeans had never known. Europeans and Native Americans coveted one another's strange things, so they traded. This process, called the Columbian Exchange, forever changed the world.

The Columbian Exchange revolutionized cuisine around the world. Before the Columbian Exchange, Italians did not have tomatoes. The Irish did not have potatoes. Europeans brought these items, and many more, back with them from the Americas. Similarly, Native Americans did not have beef or pork until Europeans brought them. Native Americans did not have coffee either. They also did not have wheat or rice. Native Americans had chocolate, but Europeans had sugar. Without the Columbian Exchange, therefore, the modern chocolate bar could not exist. The Columbian Exchange made modern-day cuisine possible, especially barbecue.

Barbecue has its origins in the first encounters between Europeans, Native Americans and Africans. Out of the interactions between different cultures, colonial Americans developed the cooking method, food and social function known as barbecue, which became a staple of social and political life in the English colonies.

As the descendants of these colonists migrated to the Deep South, they took their customs with them. Through the processes of cultural interaction and migration, barbecue arrived in Alabama, where it became entangled in questions of power, status and freedom. The story of Alabama barbecue, therefore, begins in the first moments of contact between previously unknown peoples.

Barbecue and the Columbian Exchange

Native Americans, Europeans and Africans each contributed to the development of the cooking technique, food and social event that became barbecue. Native Americans provided the method. Europeans contributed new meats and new sauces. Enslaved Africans provided the labor, which means they had significant influence over the perfection of the recipes and techniques.

On Columbus's first voyage in 1492, he and his crew encountered the Taíno people in present-day Cuba, where they learned about barbecue. Near Guantanamo Bay, Columbus's crew witnessed these indigenous people cooking hundreds of pounds of fish over the indirect heat of embers. After the cooking had finished, the entire community gathered, seemingly without regard for social status or wealth, for the feast. Europeans observed a similar cooking method and social ritual throughout the Caribbean.[1]

When Europeans arrived on the eastern seaboard of North America, they observed local Native Americans barbecuing meat in a similar manner as the Taíno people of Cuba. In 1588, English explorer Richard Grenville and his crew met indigenous people in present-day North Carolina. On this expedition, John White served as Grenville's official cartographer. In addition to his mapmaking duties, White also depicted the lives of the indigenous people in a series of watercolor paintings. In Europe, artists took White's paintings and reproduced them with their own additions. In one of these images, Native Americans cook fish on a wooden framework over a fire.[2]

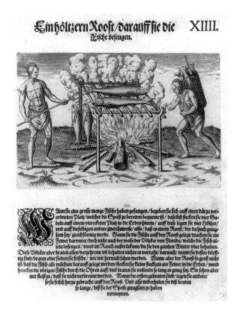

In 1588, Richard Grenville journeyed to the East Coast of North America. Here, his official cartographer, John White, observed Native Americans grilling fish on a wooden frame over a hot fire. He preserved his observations in a watercolor painting. When Theodor de Bry engraved White's image, he added two semi-nude indigenous men. *Library of Congress.*

Europeans came to understand Native Americans through these images, which often contained equal parts truth and fiction. Despite never observing native people, engraver Theodor de Bry, who produced many images of the Americas, embellished White's original watercolor with images of cannibalism. With these artistic additions, de Bry and other European artists mythologized the savage nature of the Americas and its people. Among Europeans, barbecue became associated with barbarism. Strangely, barbecue's barbarism added to its appeal because European society had a rigid moral code. For many Europeans, barbecue provided an outlet for repressed desires.[3]

In travel journals, Europeans commented on this newly discovered cooking method, which required a wooden framework, low fire and extended cooking time. According to a European observer, the indigenous people "broil their fish over a soft fire on a wooden frame made like a Gridiron." On a framework of green wood, or *barbacoa*, the natives kept the food about two feet above the embers to avoid burning. Under the framework, they built "so small a fire" that "it requires a whole day to make ready their fish as they would have it."[4] To European observers, this cooking method would have seemed strange yet familiar.

Before contact with Native Americans, Europeans did not barbecue meat but instead roasted and smoked it. In Europe, wealthy people roasted meat, but only for special occasions because it required special

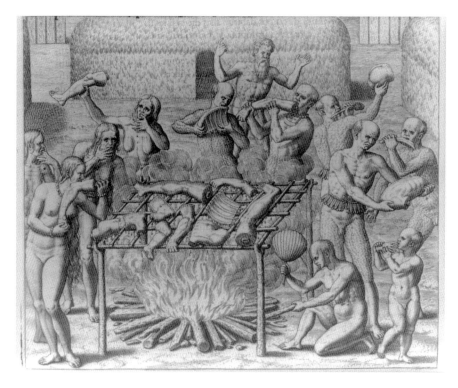

Based on John White's watercolor painting of fish, engraver Theodor de Bry, who never observed the native people of North America, produced this image of Native Americans barbecuing human body parts. *Library of Congress.*

equipment and constant attention. Unlike roasting, the indigenous barbecue utilized indirect heat and gathered people from across the socioeconomic spectrum. In addition to roasting, Europeans had a long history of smoking meat. By smoking meat, they preserved it long after the slaughter and utilized every piece of the animal. Unlike smoking as Europeans understood it, the indigenous people's barbecue took place outside in open air, not in a smokehouse. To the Europeans, therefore, the Native Americans demonstrated to them an entirely new cooking method and social ritual, even if it somewhat reminded them of home.[5]

For Columbus's predominately Spanish crew, the sight of the barbecue might have reminded them of the *txarriboda* because of its festival-like qualities. Every year, Basque farmers revel in the *txarriboda*, an ancient tradition that celebrates the slaughter of hogs. Throughout the day of the feast, people prepare the smoked sausages and hams for the winter. After the work of slaughtering and preparing the meat, they enjoy a massive feast,

dancing and singing. Although Europeans had encountered something new in these foreign lands, they had a reference point to understand it, and they embraced the new form of cooking.[6]

When Europeans adopted barbecue, they contributed new meats and new techniques. Although they witnessed Native Americans using the technique to prepare fish, game animals and, apparently, reptiles, Europeans used their newly acquired barbecue skills to prepare their own animals. Unlike Native Americans, Europeans had domesticated livestock, such as cows, goats, sheep and pigs, among others. Europeans barbecued all of them.

Among the many animals Europeans brought to the Americas, pigs thrived in the wilderness. In 1493, Columbus carried eight pigs with him on his second voyage to Hispaniola. In 1539, Hernando de Soto took some of the descendants of these pigs to North America, where they quickly spread across the continent. They are the ancestors of the wild pigs, including the Arkansas razorbacks, common in the Southeast today. In 1540, Hernando de Soto and his expeditioners encountered the Chickasaw tribe near present-day Tupelo, Mississippi. To forge an alliance with the Chickasaw, de Soto flattered the native people with massive feasts. Before refrigeration, people only barbecued meats to feed crowds large enough to consume the entire animal. The Spaniards, therefore, chose to barbecue pigs in honor of the Chickasaw chiefs, who would never have eaten pork before this encounter. In return, the Chickasaw chiefs presented food and clothes to the European travelers. Although this particular alliance between the Spanish and the Chickasaw did not last, barbecue had brought these people together.

In 1607, the English brought pigs with them to Virginia, where they outpaced other livestock in the colonies. Pigs reproduced quickly, did not require much attention from busy farmers and yielded large amounts of meat. These qualities made them ideal for the colonists. The pigs foraged for food in the wilderness. Unlike contemporary pork raised on commercial farms, these pigs would have been much leaner and tougher, which made them ideal subjects for the tenderizing forces of low heat in the barbecue pit. In journals and account books, Virginians counted many more pigs than other animals, if they even bothered to count them at all. When colonial Americans barbecued meat, it was likely pork, but it could have been any of the other animals that local farmers happened to have on hand. [7]

Europeans also contributed sauces. In travel accounts of indigenous barbecues, Europeans do not mention basting or sauces. In Europe, people basted their roasts with a variety of sauces. In France and Germany, people

preferred to use mustard-based sauces. In England, people developed tart sauces out of vinegar. According to one medieval recipe, Europeans roasted birds with a sauce consisting of mustard and vinegar seasoned with powdered ginger and salt. In another recipe, author Thomas Dawson recommends basting meat with a sauce of vinegar, ginger and sugar.[8] These sauces bear resemblance to modern-day barbecue sauces, like the mustard-based sauces in South Carolina and the vinegar-based sauces of North Carolina. When Europeans came to the western hemisphere, they introduced basting and sauces to barbecue to help keep the meat moist as it cooked.

When barbecue took hold in North America, enslaved Africans barbecued food for white families and white events but also for themselves. At most barbecues, enslaved people smoked meat on poles situated over long, earthen trenches that glowed with hot coals. When enslaved Africans held their own barbecues on holidays, white masters often donated meat, such as pork but also beef, mutton and other meats, for the event. Enslaved people smoked the meat and served it alongside food gleaned from Native American recipes, such as cobbler, sweet potato pies and corn bread, as well as European treats, such as cakes, pies and custards.[9] Through the process of cultural exchange, the modern-day southern institution of barbecue was born. Even in the food's infancy, barbecue as a cooking method and a social ritual consisted of many of the elements that would eventually define the food in Alabama.

Barbecue and Power in Early America

In the seventeenth century, colonial Virginians made barbecue a staple of their events held on behalf of community development and politics. In 1607, English settlers arrived in Jamestown, Virginia, where they barbecued meat because of its similarity to the traditions of their homeland. For the most part, the settlers of colonial Virginia came from southern and western England. In these parts of England, people tended to roast and broil their meat. They also had a vigorous festival culture, which colonists replicated in their new homes.[10]

In colonial Virginia, the tidewater planters used barbecue to demonstrate their hospitality and generosity because these qualities testified to elite social and economic status. The tidewater planters created rituals and crafted appearances to separate themselves from most colonists. To these ends, they built great houses capable of hosting large parties. They refined their

churches and homes with the finest materials. They also provided food and drink to people at community gatherings, such as court days, horse races, militia musters and election day. At these events, wealthy Virginia gentlemen competed with one another for the affection of the masses. Due to its ability to feed large groups of people, barbecue satisfied these purposes.[11]

Political aspirants, including George Washington and Thomas Jefferson, hosted barbecues to treat voters for their support. At barbecues, politicians nurtured constituents. Such events also provided common people the opportunity to gather and express their freedom through eating and drinking. At these political barbecues, candidates had to walk a fine line and not appear too eager for power. In fact, they did not at all represent the barbecue and alcohol as an enticement to vote or as a reward for voting a certain way. Instead, politicians portrayed the barbecue as part of their obligation to their poor neighbors. George Washington explained, "I hope no exception were taken to any that voted against me but that all were alike treated and all had enough."[12] They insisted that they treated all voters, regardless of their allegiances. To maintain an illusion of distance and disinterest, politicians often had other wealthy gentlemen provide the barbecues on their behalf.[13]

The guests ate and drank a lot, which entailed high costs for the hosts. In 1758, two notable candidates for Virginia's House of Burgesses racked up massive bills in pursuit of political office. Washington procured rum, punch, wine, beer and cider for his guests. Another candidate, Matthew Marrable, treated voters from a militia company to a feast of seven barbecued lambs. He also provided thirty gallons of rum. Despite the lavish feast, or perhaps because Marrable went too far, he lost. In this time and place, Americans organized themselves in a hierarchical, deferential society. As voters started to expect barbecues and alcohol in exchange for support, the tidewater elite had the only true chance to win because only they could afford to demonstrate their hospitality and generosity on such a large scale.[14]

Barbecue Arrives in Alabama

After the American Revolution and the War of 1812, Americans spread out from the eastern seaboard into the Deep South along the Gulf Coast, including Alabama. During the first two decades of the nineteenth century, fervent nationalism and economic boom inspired people to settle in the Deep South. From 1810 to 1820, the population of the Deep South

doubled as people pursued the lucrative profits that cotton promised. In 1819, Alabama became a state. The settlers of the Deep South and Gulf Coast arrived either voluntarily or by force from other parts of the United States, the Caribbean and Africa, which made the region one of the most ethnically and culturally diverse places in the world. Many of the settlers migrated to Alabama and Mississippi from the older states on the eastern seaboard, including Virginia, Georgia or the Carolinas, but also through Tennessee and Kentucky.[15] In these places, barbecue had a strong presence. In their new homes, migrant settlers re-created the cultural norms and resurrected their old institutions. With these settlers, therefore, barbecue arrived in the region.[16]

In the early nineteenth century, Americans started to settle the Deep South because the region promised financial wealth and social status. Like many other people, Bishop Nicholas Hamner Cobbs left Virginia and eventually settled in Alabama. Cobbs explained that settlers had heard "marvelous accounts" of "the fertility of those virgin lands." They believed that "the productions of the soil were commanding a price remunerating to slave labor as it had never been remunerated before." The region attracted other sorts of people, as well, who "had come out on the vague errand of seeking their fortune, or the more definite one of seeking somebody else's."[17]

The first settlers of Alabama consisted mostly of men with rough spirits. Cobbs recalled, "The proportion of young men, as in all new countries, was great." He added, "The proportion of wild young men was, unfortunately, still greater." He observed that these demographics resulted in a "violent disruption of family ties" and "a sudden abandonment of the associations and influence of country and of home." As a result, Alabama had a "new and seething population in which the elements were curiously and variously mixed with free manners and not over-puritanical conversation."[18] In Alabama, according to Cobb, "vulgarity, ignorance, fussy and arrogant pretension, unmitigated rowdyism" and "bullying insolence" characterized society. These wild young men embraced barbecue because of its humble, rustic, savage origins.

With the lack of a unifying ethnic or religious identity, Americans used the barbecues to create and reinforce their national identity, practice democracy, celebrate their nation, reinforce its founding principles and rally electoral support.[19] In the earliest years of nationhood, Americans had already adopted barbecue as the main event on Independence Day. As towns grew across the South, people enjoyed barbecue and drinking to celebrate independence. At these events, people toasted the presidents, read

the Declaration of Independence, blasted fireworks into the sky and ate and drank as much as possible in an expression of freedom. Often, candidates appeared at these barbecues to make their partisan appeals, just as they had since colonial days.[20]

Barbecue had become a major component of democracy and a symbol of the new world order among white, nineteenth-century Americans.[21] At barbecues, people made a point to enjoy themselves, often to excess. As barbecue had become associated with savagery, white Americans seemingly embraced the hedonistic nature of the food as a symbol of their freedom and independence.[22] They considered these events an outlet for expressing and celebrating liberty and an escape from civilized life. Through barbecue, therefore, common people rebuked the country's elite, especially candidates like John Quincy Adams, who received his education and acquired his manners in Europe. By the Jacksonian era, barbecue had become an important symbol of liberty and democracy in the United States, especially in Alabama.[23]

In the 1820s and 1830s, Andrew Jackson's supporters turned to the barbecue to rally grass-roots support, and the political barbecue proliferated across the South. For decades, American politicians had barbecued meat for their supporters. Among Jackson's supporters, however, barbecue became entangled with democratic spirit because the food reminded them of their candidate: grassroots, savage and American.[24]

Alabamians came to love politics and barbecue in equal measure. Cobbs recalled that Alabamians had many sources of entertainment, but "the all-absorbing and exciting theme was politics." In small towns, locals would construct a "rude platform" under "the shade of a spreading tree." On this platform, the "champions of the Whig and Democratic creeds" stated their positions and challenged one another. According to Cobb, "Folk would come from far and wide to enjoy [politicians'] feats and flights of oratory, in the intervals of which a band would play, while refreshment was provided by a monster barbecue." These political barbecues attracted rough crowds, who "experienced a sense of incompleteness if the debate and the day did not wind up with a duel."[25] In antebellum Alabama, barbecue fueled democratic traditions throughout the state.

In the earliest years of statehood, the volunteers of Alabama's numerous local militias mustered together once a year for a day of drilling and fanfare, and "barbecue was often the temptation to make a full muster." Politicians appeared at these events and at other, similar occasions.[26] Likewise, politicians attended the barbecues hosted by the community.[27]

During campaign season, the candidates did not tend to host the barbecues but rather attended them as guests of the people. During the nineteenth century, civic and social leaders in Alabama hosted barbecues and invited local people to attend them with the promise of appearances by all the local candidates. Unlike the previous incarnations of the political barbecue, the people hosted the events and expected the candidates to come to them.[28] At these barbecues, no single person provided the food to demonstrate their wealth and generosity. Instead, the people in the community each contributed something, although a particular person might serve as the host. Due to the potluck quality of these events, guests often brought whatever they could spare, so barbecues in Alabama consisted of beef, mutton, chicken, oxen, venison or turkeys, depending on local availability.[29]

By the nineteenth century, Alabama barbecue, like barbecue elsewhere in the South, had not yet become dominated by pork or chicken or any other specific meat. Instead, hosts of political barbecues served a variety of meats gathered from nearby farmers. At an 1840 barbecue in Autauga County, "the people sent fat mutton, beef, pork, poultry, to the barbecue pits."[30] According to a reporter from the town of Elyton, in present-day Birmingham, cooks prepared the meats for another barbecue on "poles stretched across shallow pits, under the shade of the trees, in which very hot red coals are kept....Constant turning and seasoning with vinegar and condiments during the baking result in giving them a delicious flavor in no other manner obtainable."[31] At this point, Alabama barbecue tended to look like barbecue in other parts of the American South, but it did have a unique political significance.

Without an established planter class, Alabamians voted and held office regardless of property, and they often ousted incumbents in local elections. The state was more democratic and liberal compared to other southern states. Alabamians crafted a state constitution with a liberal and democratic character, which reflected the concerns of small farmers. Alabamians scrutinized the work of legislators and governors in search of any sign of tyranny.[32] To mobilize these energetic voters, barbecues played a prominent role in Alabama's campaigns. In fact, they played such an important role in politics that some people worked to eliminate barbecues.

CHAPTER 2

"FREEDOM WHICH KNEW NO RESTRAINT"

The Madison County Anti-Barbecue Reform Movement, 1820–1840

I n the early nineteenth century, Americans lived through an era of
immense change as traditional politics and society, which had ordained
deference to a natural aristocracy, gave way to an emerging sociopolitical
order emphasizing individual liberty, democracy and popular sovereignty.
During this period of change, American national and local politics became
feisty as people advocated on behalf of one worldview over another.

In national politics, these divisions energized the electoral contests
between John Quincy Adams and Andrew Jackson. In the 1820s, politicians
like Adams, the son of President John Adams, fell out of favor with a lot
of people. To many Americans, Adams and his ilk seemed bookish, elitist
and out of touch. Instead, politicians like Andrew Jackson, a military
hero, became popular as common white men gained more political power.
In the 1824 presidential election, Jackson earned more votes, but Adams
became president because the Federalist Party controlled the House of
Representatives, which determined the winner when no candidate secured
a majority in the Electoral College. In 1828, Jackson finally won election
to the presidency, which to many people signaled the triumph of a new
democratic era. The adherents of the traditional social and political order,
however, launched reform movements to curtail the effects of freedom and
democracy on society.[33]

A series of nineteenth-century religious developments changed standards
of behavior for the emerging middle class, which set out to improve the
morality of the nation and its citizens. During the Second Great Awakening,

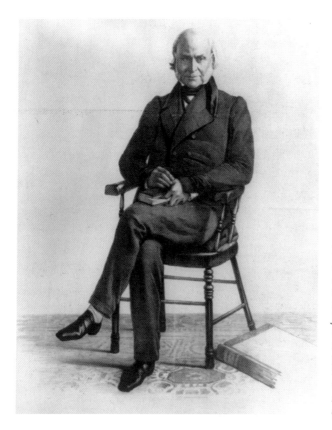

In 1824, John Quincy Adams defeated Andrew Jackson in a disputed election. He served one term before Jackson defeated him. As America became more democratic, politicians like Adams fell out of favor with the rough, rugged American public. *Library of Congress.*

which reached the Tennessee River Valley in the 1820s, evangelical converts viewed themselves and society as potentially perfect, which served as the underlying premise of reform movements. As part of the conversion process, evangelicals often condemned their past behaviors and lamented the lack of morality they saw in one another. As a result, reformers started the abolition and temperance movements, among others.[34]

The nationwide struggle between reform and democratic spirit played out in a local movement in Madison County, Alabama, to eliminate barbecue. Alabamians reveled in the era's political barbecues, where candidates campaigned for votes as the people ate and drank. But the mixture of politics, food and especially alcohol raised the ire of nineteenth-century reformers, particularly in Madison County, who condemned political barbecues as an insult to democracy and good government.

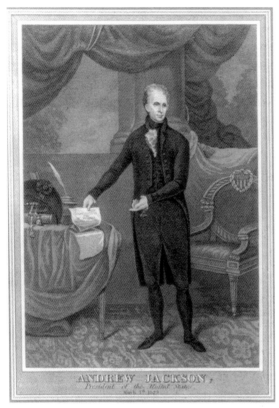

Left: In 1829, Andrew Jackson took the oath of office and became president of the United States. His supporters had hosted barbecues to generate enthusiasm and mobilize voters. *Library of Congress.*

Below: In 1834, cartoonist Henry R. Robinson portrays Jackson being barbecued over the fires of public opinion. As his supporters had used barbecues to make him wildly popular with the public, they now used the same method to criticize him after his unpopular decision to destroy the Bank of the United States. *Library of Congress.*

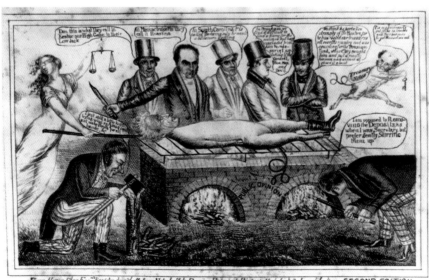

The Settlement of Madison County

Although Alabama became a territory in 1817, Americans had already started settling in that part of the Mississippi Territory. Before large-scale migration to the area began, cattle herders settled along the Tombigbee River near Spanish-controlled Mobile, and squatters settled along the Tennessee River in present-day Madison County.

In pursuit of promising rumors of wild game and a valuable water source, a few Tennesseans migrated to the area and became the first white settlers of present-day Madison County. Among these settlers, John Hunt built the first cabin on the banks of Big Spring. Soon, a few families took a similar southward journey and settled the area. They lived here for a few years without any legal claim to the land.[35]

In 1809, when land became available for sale, only a third of the original squatters purchased their land and legally remained. John Hunt returned to Tennessee. Instead, wealthy planters acquired the best land in Madison County and moved their families from Virginia and Georgia to Alabama, where they hoped to improve their political and social power.[36]

When the wealthy planters arrived in Alabama, they intended to take control of government. In Virginia and Georgia, these planters had become politically powerful. Upon their arrival in Alabama, they set out to dominate politics there as well.[37] According to planter George R. Gilmer, these wealthy families formed a "most intimate friendly social union."[38] They married within the group, thus creating a tightknit community of elites. Although these wealthy planters had the best land, the most money and useful connections, the remaining Tennessee-born homesteaders bought the rest of the land and became the area's majority, which made them politically powerful.

Politics in Alabama

Immediately, the wealthy planters and homesteaders became embroiled in class-based political conflict as they competed to remake the town of Hunt's Springs to suit their group's needs. They formed separate factions: the Royal Party and the Castor Oil Party. Leroy Pope, a wealthy planter, led the Royal Party, which consisted of the rest of the planting class. The homesteaders named their party in honor of John Hunt, who reportedly ran a castor oil

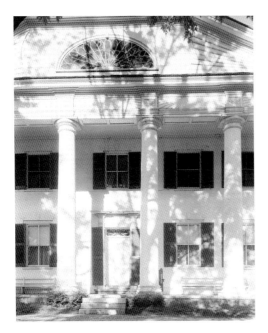

In 1814, Leroy Pope, known to many as the "Father of Huntsville," built this stately home on present-day Echols Avenue just outside downtown Huntsville in the Twickenham neighborhood. At one point, Pope led an effort to change the name of the town from Hunt's Springs to Twickenham. *Library of Congress.*

shop before moving back to Tennessee. Although Hunt had moved away, the small farmers continued to invoke Hunt's name to claim that they, not the wealthy planters, truly controlled the area.[39] The power struggles between the two classes defined the region's politics for decades.

After settling the area, the wealthy planters attempted to erase any memory of the squatters from the local landscape and gain control of the county's representation in the territorial legislature. Pope, a descendant of English poet Alexander Pope, changed the name of the town from Hunt's Springs, after John Hunt, to Twickenham, the poet's hometown. When Madison County residents gained representation in the territorial legislature of Mississippi, the wealthy planters nominated members of their tightknit group to take the seats.

Instead of deferring to the social and financial elite, the homesteaders nominated their own candidates to take the seats in the territorial legislature. They nominated Hugh McVay, an original squatter in the area, and Gabriel Moore, who had served as a tax assessor.[40] They won. When they took their seats, they successfully changed the name from Twickenham to Huntsville in honor of John Hunt, thus winning the hearts of most of the Madison County electorate. They continued to win election to the legislature, and they both eventually became governors of Alabama. Moore also served in the U.S. House of Representatives. Although the homesteaders had the most

political success in the territorial period, some wealthy planters eventually did earn seats in the legislature. They became especially powerful as Alabama neared statehood.[41]

Upon joining the Union in 1819, Alabamians protected the power of the small farmers by ratifying the most liberal state constitution of the period. In Alabama, all white men could vote regardless of property or wealth. They did not set any property qualifications for holding office, either. As a result, Alabama had an energetic and large electorate, who used their right to vote often and without deference.[42]

Alabamians wanted politicians who responded to the will of the people, so they set short term limits for most offices and curtailed the power of the executive branch. In antebellum Alabama, governors served for only two years. The governor had veto power, but the state legislature could overturn the veto with a simple majority. In the state legislature, representatives served for only a single year, and senators served for three years.[43] In Alabama, people frequently went to the ballot box, so candidates had to campaign incessantly to keep their jobs. For this purpose, they turned to barbecue, which appealed to the rough, egalitarian-minded, freedom-loving Alabama electorate.

ALABAMA POLITICAL BARBECUES

Barbecues played a prominent role in campaigns because they mobilized the state's energetic electorate. Unlike colonial-era political culture that required candidates to host the barbecues, private citizens hosted Alabama's political barbecues and invited the candidates to come and meet the people. Barbecue, like politics, had become less deferential and more communal, which had implications for the food and for politics.

As the people rather than the candidates hosted the barbecues, they resembled a potluck with various meats and sides, some of which remain staples of modern barbecues. The people, often farmers, provided whatever they could afford to spare. The meats would likely have included a combination of pork, beef and mutton. People also barbecued other livestock, such as goats, and game animals, like squirrels and deer.[44] They prepared the meat in earthen pits over coals. People would have brought side dishes, including traditional European foods, such as custards and cakes, as well as new recipes learned from native inhabitants, such as sweet potatoes, maize and cobblers.

When people hosted barbecues, they wanted the candidates and as much of the electorate as possible to attend. By hosting barbecues, citizens gained social status by demonstrating their hospitality. On July 28, 1827, John Weaver and John Buzby hosted a barbecue at Weaver's farm located about ten miles east of Huntsville. A week prior to the event, they advertised the event in Huntsville's *Southern Advocate*. They promised a "splendid barbacue" and that "the candidates and others will be expected."[45] By placing the advertisements in newspapers, the hosts reached a wide audience and signaled their intention that as many people as possible come and meet the candidates.[46]

If candidates wanted to gain the favor of Alabama's rowdy, egalitarian electorate, they had to overindulge in food and drink at barbecues, so reformers targeted the barbecues for contributing to immoral behavior and bad politics. A reformer from Huntsville explained the candidates' precarious position. In a July 1827 column, an anti-barbecue reformer, who wrote under the penname Barbacuensis, asked, "What candidate can be elected unless he goes to the barbacues?" He added, "What voter can judge of a candidate's claims and qualifications unless he has first ate his board, and drink his cup?—which, being interpreted, means, eaten his bacon and drank his whiskey."[47] In April 1828, the editor of *Southern Advocate* similarly assessed the candidates' situation. The editor explained that civic leaders simply had "to cry shote, shote, [a young pig] whiskey, whiskey," and "the poor candidates" had to "obey the summons, or abandon all hopes of their election."[48] Candidates did not have a chance of winning if they did not attend the barbecues.

Political barbecues consisted of copious amounts of food and drink. Barbacuensis explained that the whiskey keg "held within its mystic hoops the charm of universal solace" and "was ever flowing, ever full." According to Barbacuensis, "The law givers of modern days not only minister to these virtuous appetites of their constituents, but they must…evince a hearty fellowship by partaking with them—and that too in no stinted measure."[49] When a person announced his candidacy, the editor explained, the candidate, in effect and without words, had proclaimed to the voters "that he can eat his weight in raw shote, and drink whiskey enough to float a seventy-four," referring to a seventy-four-gun naval ship.[50]

Due to the presence of alcohol and political passion at these events, violence often broke out. In 1843, a posse chased down a barbecue guest over the course of multiple days because he stabbed someone at a barbecue in Coosa County, Alabama. When they found the perpetrator, "he threw

open the door and discharged his last load of ammunition, and rushed out and engaged in hand to hand conflict" before the mob killed him.[51] At political barbecues throughout the region, including Alabama, guests often succumbed to the forces of alcohol and turned violent.[52]

At barbecues, people gathered across class and generational lines to mingle with one another and with the candidates. Barbacuensis explained that "all who were not rich enough to stay at home, and some I thought were, were feasting and drinking at the barbecue." He did not understand why people with the means to feed themselves would humble themselves by attending barbecues with the masses.[53]

In addition to the rich and poor, the young and old also attended these political barbecues. Barbacuensis observed that the barbecues had not neglected the "rising generation" because "little prattlers just escaped from the nursery" attended these barbecues alongside "the more advance striplings."[54] Although only white adult men could vote, Alabamians attended these barbecues regardless of age, sex or even race.

Women did not have the right to vote, but they still participated at political barbecues. During the 1820s and 1830s, Alabama barbecues mostly catered to male voters. In the 1840s, women became an increasingly visible presence in national and local politics. The Whigs, who supported many reform movements, including temperance, hoped white middle-class women would identify with these reform movements and persuade their husbands to support their party. So, Whigs specifically targeted these women to attend their barbecues. The presence of women at political barbecues eventually curbed violence and alcohol consumption, as well. They helped legitimize barbecue as an acceptable place for politics and socializing.[55]

Enslaved African Americans had a presence at these events as well, serving as pit masters. At the typical barbecue, a white male supervised the barbecue pits while black slaves did the cooking for the white guests. As pit masters, they played a prominent role in the success of these events by infusing the food with their cultural techniques and recipes.[56] Despite no voting rights, African Americans not only prepared the food that had become emblematic of American democracy, but they also participated in the festivities.

While it seems unlikely that enslaved Alabamians frequently attended these events as invited guests, they seemed to have felt inspired by the freedom and liberty exercised at these occasions and enjoyed them from time to time. They may have done the cooking and, therefore, had earned the right to enjoy some food or drink. Or, they simply attended with or without their masters' approval. Regardless, they attended, which had

implications for social order in Alabama. Observing a barbecue in August 1827, Barbacuensis noted that "the joy of the occasion was not confined to the voters exclusively." The reformer added, "In such an outpouring of liberty and unbounded license, slavery forgot its chain, and the tawny sons of Africa danced, sung, and balloeed [*sic*] in sympathetic freedom."[57] Much like today, Alabamians gathered across class, generational, sex and racial lines to enjoy barbecue. In the nineteenth century, however, the mixing of the races and sexes at barbecues made them the targets of criticism.

Barbacuensis and *Southern Advocate*

In late 1820s Madison County, where two decades of class politics had made the transition from traditional to contemporary society especially fraught and tense, an anti-barbecue reform movement took hold in reaction to the perceived threat barbecues posed to political and social order. The reformers criticized the electioneering of the candidates. They also condemned the electorate's consumption of alcohol, eating habits and licentious behavior.

At barbecues, candidates competed for votes among the inebriated, gluttonous electorate, which Barbacuensis criticized as part of the anti-barbecue campaign. In July 1827, Barbacuensis explains, "we had seen at the barbacues…some happy sovereign who had been reveling in all the ecstasies of gratuitous whiskey and enjoying freedom which knew no restraint" and had "fallen asleep in paradise of perfect unconsciousness."[58] At barbecues, "the sun went down, nor ceased the drinking there" while "tumultuous shouting shook the midnight air." Instead of these drunk men, Barbacuensis believed that power should reside with those who "feel respect for heaven" and "worship whiskey, less than God." He preferred that men "turn at last from shote and grog" and instead "act the man, and not the hog."[59] Reformers like Barbacuensis tended to believe that power should reside with the sober and industrious, not the masses of people considered inferior because of their social class and perceived immorality.

The editor of Huntsville's *Southern Advocate* also detested the gratuitous eating and drinking present at political barbecues. The editor warned that the quantity of the food and drink consumed would lead to "actual and immediate death" except in some cases of "fire proof and case hardened stomachs." These people, who always ate and drank to excess, avoided the "awful consequences" of these acts of "suicidal indulgence." The editor

disapproved of the barbecues in part because of their cost. He rejected the "pecuniary sacrifices" annually "offered up at the shrines of gluttony, and debauchery."[60] Like many reformers, the *Southern Advocate* editor opposed the consumption of alcohol, especially when it intersected with the region's political process.

From the perspective of reformers, the electioneering that took place at barbecues signaled a descent into mob rule. In a poem, Barbacuensis described his view of a typical barbecue:

> *Did'st ever see a Barbacue? For fear*
> *You should not, I'll describe it you exactly:*
> *A gander-pulling mob that's common here,*
> *of candidates and soveren stowed compactly,*
> *Of harlequins and clowns with feats gymnastical*
> *In hunting shirts and shirt-sleeves—things fantastical;*
> *With fiddling, feasting, dancing, drinking, masquing*
> *And other things which may be had for asking.*[61]

Barbacuensis did not have a favorable opinion of the people and their behavior at barbecues, and he lamented that upper-class people attended these events alongside their unruly social subordinates. Barbacuensis had expected to see the lower classes partaking in the free food and drink at the barbecue but did not expect wealthier people to humble themselves by attending these shameless, barbaric feasts.[62]

Reformers worried that barbecues distracted men from their duties to their homes and families. The reformers lamented the lack of industry displayed by the guests at these barbecues. "At the most hurrying season of the year," wrote Barbacuensis, barbecue guests "forsake all and follow barbacues for three months at a time, in the infancy of the crops, and when the sands of time are literally golden." Not only did these people neglect their responsibilities, Barbacuensis argued, they did not care. He wrote, "Not a face was furrowed with care-worn wrinkles for debts unpaid, contracts broken—or wives and children houseless, unfed and unclothed."[63] Similarly, the *Southern Advocate* editor argued that the "fatal gales of the stormy seas of barbecue politics" turned "strong and staunch" young men into "shattered and shipwrecked" beings. He argued that "gorging upon raw shote" and "swilling a species of liquor little less than liquid fire" resulted in a circumstance "worse than actual and immediate death."[64] When the reformers observed barbecues, they expressed disgust

at the amount of food and drink consumed because of its unhealthy effects on the individual and also the community.

According to reformers, barbecues hurt the individual, but they also damaged the community. The *Southern Advocate* editor argued, "The time and money that are thus abandoned to the wildest wastefulness," although disastrous, seemed "dross indeed when one considers the injury, the utter ruin" that barbecues "inflict upon health and morals." Although reformers probably exaggerated claims of drunkenness and licentiousness, it seems likely that they based these critiques in truth because they all emphasized the excess of liberty at these events. The reformer concluded, "The moral death which results from a regular attendance upon these barbecues, is no less certain and awful than that which merely takes the animal life of the victim." These events had wider implications for the community. "In some instances," critics argued, "the whole community feels the pang and writhes in sympathetic agony" due to the lack of morality demonstrated at these events.[65] Without a strong moral community of healthy, industrious citizens, many reformers feared that democracy would fail.

Reformers contended that barbecue culture had led to lower-quality candidates. In one of his critiques, Barbacuensis lamented, "A vast majority of barbacue candidates have as much brains in their stomachs as in their skulls, so that in judging of their merits, there can be nothing lost in making a direct and exclusive appeal to the abdomen."[66] Rather than focusing on mental capabilities of the candidates, Barbacuensis believed that the electorate had new criteria by which to judge the candidates: "Is not the seat of qualification and merit transferred from the hand and heart and confined, exclusively, to the stomach? The question now, is not, what is his mental capacity? but, what are the dimensions of his stomach? Not, does he read and think? But, does he eat and digest?"[67]

In other words, the reformer condemned the barbecues because the electorate did not wisely choose their candidates. The electorate wanted someone to act like them instead of superior to them. The reformers wanted candidates to remain above the masses.

In the new political culture, from the perspective of reformers, candidates and voters often did not have a personal relationship with one another. According to Barbacuensis, candidates often picked out a single voter "to entertain him with some very affectionate inquiries about his subliminary affairs" but instead revealed total disinterest in voters' lives.[68] Barbacuensis had a nostalgic, romantic view of politics in previous decades. In an era of deferential politics, he believed, politicians and their constituents had

a personal, often paternalistic relationship. Now, from his perspective, democracy worked like a machine with each candidate providing favors, including alcohol, to secure as many votes as possible.

Despite the attempts of local reformers to eliminate barbecues, they continued in Alabama throughout the antebellum period and beyond. For the most part, candidates who refused to participate in these events often suffered defeat on election day. In Alabama, especially, barbecues proved more popular than the candidates who opposed them. In Madison County, candidate Josef Leftwich took a stand against barbecues by refusing to attend them; he finished seventh out of nine candidates in the race to serve as tax collector.[69] Alabamians would rather get rid of their politicians than their barbecues.

OLD-FASHIONED BARBECUE

Alabama Barbecue in the Eras of the Civil War, Reconstruction and Redemption, 1850–1890

B y the time the Civil War ended in 1865, more than 600,000 soldiers and 50,000 civilians had died. When the war ended, more than 4 million enslaved people gained their freedom because of the Emancipation Proclamation, Union victory and the ratification of the Thirteenth Amendment, which eliminated slavery throughout the land. In the wake of the war, Americans ratified the Fourteenth and Fifteenth Amendments, which protected the citizenship rights of African Americans and black men's voting rights.[70] The Civil War changed almost everything.

As soon as the war ended, Americans went to work trying to memorialize their respective causes and define the meaning of the deadly conflict. African Americans emphasized the war's role in ending slavery. For them, the Civil War served as a beginning of a new era for the black race, in which they would eventually attain equality. Meanwhile, white southerners romanticized and mythologized the Old South. They pined for the days preceding the sectional crisis and the war. They disseminated images of gallant gentlemen and southern belles.[71] In the postwar period, black and white Americans, including Alabamians, appropriated barbecue for their respective causes.

From the 1850s to the end of the nineteenth century, barbecue remained a vital component of Alabama's political culture, but as politics changed, so did barbecue. In many ways, barbecue as a food and a social event seemed unchanged. Alabamians continued to cook a variety of meats and gather with one another around a common table for community and political purposes. As they ate, political speakers took the stage and debated important

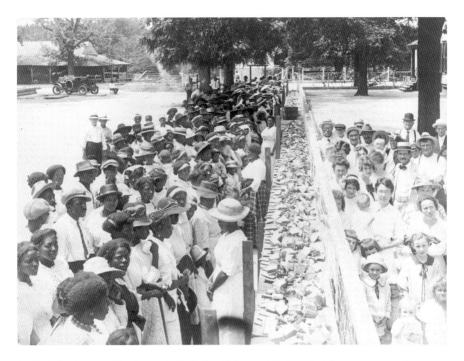

At F.M. Gay's annual barbecue in Eufaula, Alabama, black and white southerners dine together, yet separately, on barbecue and white bread. *Library of Congress.*

topics, just as they had done in antebellum days. These postwar barbecues, however, differed in one noticeable way: black men, who now had the right to vote, attended these events with their families and friends as invited guests, or they held their own events.

Additionally, black and white Alabamians imbued new meaning on barbecues. For white Alabamians, barbecues provided an opportunity to reflect on the past and honor it. The barbecue reminded them of an imagined idyllic past. They used these events, therefore, to raise money for monuments to the Confederacy. Black Alabamians used barbecue, or even admonished it, to uplift their race and build a better future.

BARBECUE AND THE ROAD TO CIVIL WAR

In the middle of the nineteenth century, Alabamians continued to love their politics and their barbecue. At political barbecues, candidates debated one

another and reached out to the electorate. In 1860, Alabamians debated the most important issue facing the country: secession from the Union.

In Alabama, journalist and politician William Lowndes Yancey led the secession movement. As a member of the Fire-Eaters, he vigorously defended slavery and advocated for Alabama's secession from the Union. In 1860, he embarked on a speaking tour of the state to argue his perspective. In July, Yancey spoke at a barbecue staged at Bethel Church near Montgomery. He argued that southerners should "throw off the shackles, both of party and of the Government," and "assert their independence in a Southern Confederacy." A week later, he spoke at a barbecue in Benton, Alabama. In this speech, he advocated for the creation of the States League and a Central Southern Congress of the Leagues.[72] Near Montgomery, white Alabamians tended to favor secession, but not all Alabamians supported the creation of a new nation.

In North Alabama, many people wanted to remain in the United States. Alabama's Unionists also held public barbecues in support of their cause. In August 1860, Unionists gathered in Huntsville for a day of barbecue and political discourse. "We had a glorious day yesterday," explained a reporter, who added that the "large crowd, good barbecue, and speeches" could "change hearts of stone." The demonstration, which "surpassed anything ever before witnessed in Alabama," consisted of supporters of Tennessee's John Bell of the Constitutional Union Party. Like Abraham Lincoln, Bell opposed the expansion of slavery and secession. Unlike Lincoln, Bell owned slaves and had lived his entire life in the South, which made him palatable to southern voters. According to the reporter, "There are many good Democrats who love the Union" and who considered Bell the "man to beat Lincoln."[73]

Political Barbecue in the New South

On July 4, 1876, Americans celebrated the 100th birthday of the United States of America. Although the Civil War had ended only eleven years earlier, Americans still celebrated the birth of their nation just as they had done for a century—by attending community barbecues to feast, fraternize, celebrate and participate in political discussion.[74]

To celebrate the nation's centennial birthday, Alabamians traveled to the resort town of Shelby Springs for a barbecue. For this widely publicized

event, special trains brought in over ten thousand spectators from as far away as Anniston and Selma. They gathered on the grounds of the Shelby Springs Hotel. At the barbecue, Democrat John T. Morgan debated Republican Napoleon B. Mardis. During the Civil War, Morgan had served as a general in the army of the Confederate States of America. After the war, he may have had ties to the Ku Klux Klan. Mardis, the challenger and underdog, had worked for many years in Shelby County as a lawyer, judge and postmaster.[75]

When Morgan took the stage, he could not compete with the food for attention. Under a glaring sun, the crowd "stirred restlessly as the odor of the cooking meat reached their nostrils." With all eyes and minds focused on the nearby barbecue pits, Morgan had trouble reaching his audience. "At last the feast was ready, and the master of ceremonies poised himself to strike the dinner gong," although the candidate was still speaking. Rather than continuing, Morgan "jumped down and joined wholeheartedly in the rush for the food."[76] The hungry crowd did not seem to mind.

After dinner, Morgan completed his speech just as the train whistles beckoned passengers to prepare for the return trip. Mardis never had the opportunity to speak. Morgan won the election, and he remained in the Senate until his death in 1907. As much as barbecue had helped launch Morgan's political career, it had also helped doom Mardis to obscurity. When Mardis died in 1892, local newspapers remarked that he was "not in political touch" with most Alabamians, but "he was universally liked and esteemed as a good citizen, neighbor and friend."[77]

After the Civil War, Alabamians continued to express their politics at barbecues like the one in Shelby Springs. In many ways, these barbecues resembled antebellum affairs. The barbecues consisted of a variety of meats, gathered people together as a community and featured prominent politicians. Despite these similarities, political barbecues did not look like their antebellum predecessors in one important way: African Americans now had their freedom, and they attended these events not as cooks or property but as voting citizens.

When African Americans went to political barbecues, they participated in a chaotic political period, in which alliances constantly shifted. At times, African Americans hesitated to attend political barbecues because they distrusted their white hosts or feared violence. On other occasions, they attended as the guests of honor because of their support in recent elections. They also held their own barbecues to strengthen their own communities.

In 1866, a white con artist scammed a group of African Americans at a barbecue in Sumter County. Upon the conclusion of the war, many African Americans expected to each receive forty acres of land and a mule as compensation for their time in bondage. They based these expectations on General William Tecumseh Sherman's orders concerning the division of land in the Sea Islands of Georgia. There, African Americans did receive forty-acre plots and mules. Throughout the South, African Americans expected similar land redistribution. A con artist manipulated these rumors to his benefit. At a barbecue in Gainesville, Alabama, he portrayed himself as a representative of the government. He explained that the black locals had to demarcate their plots of forty acres. In his arms, he carried dozens of blue and red pegs for them to use. According to testimony provided by John G. Pierce of Eutaw, Alabama, the pegs "had been made by the Government for the purpose of staking out the negroes' forty acres." The con artist informed his black audience, according to Pierce, that "all he wanted was to have the expenses paid to him, which was about a dollar a peg." Within two hours, the con man made $300 and left town.[78]

In 1867, black and white Alabamians gathered at a barbecue in Yancey, Alabama, but not without hesitation. According to testimony before Congress by politician James H. Clanton, someone had spread a rumor that the white hosts intended to poison the black guests at the barbecue. Clanton, who presented a speech at the barbecue, testified that he "went out and told the negroes it was a false report that they were to be poisoned."[79] Apparently, Clanton had eased the black community's concerns because some African Americans went to the feast. At this barbecue, black and white Alabamians gathered together for a common meal, but they did not, according to Clanton, eat at the same tables.

At the time, southern Democrats advocated on behalf of white supremacy as they attempted to resurrect the South's antebellum economic, racial and social hierarchy. Nathan Bedford Forrest, who had commanded Confederate forces at the Battle of Fort Pillow that had resulted in a slaughter of black soldiers, was a member of the Ku Klux Klan. In North Alabama, Forrest hosted barbecues on behalf of the Democratic Party in his attempt to help rebuild the party in opposition to the Republican-controlled federal government.[80] When African Americans gained the right to vote, however, southern Democrats wanted black votes.

In 1870, African Americans gained the right to vote with the ratification of the Fifteenth Amendment. By and large, they supported the Republican Party, which they associated with Abraham Lincoln and emancipation.

Refusing to concede these black votes to the Republican Party, however, Alabama Democrats, who had spearheaded the movement for secession and advocated for white supremacy, used barbecues to court black voters.

During the 1870 campaign, Democrats eagerly pursued black votes in Sumter County by hosting barbecues and inviting black citizens. According to white lawyer Turner Reavis, "The Democrats in my county, and indeed in all those western counties, exerted themselves tremendously to get the colored people to vote their ticket." He continued, "They gave them barbecues and made speeches, and got colored men who were Democrats to go around with them and make speeches. The hatchet seemed to be buried between the two races during that canvass."[81]

In 1872, Barbour County Democrats hosted a barbecue and invited all the local residents, regardless of race. To prevent African Americans from attending this barbecue, black Republicans spread a rumor that the white Democrats intended to poison the meat. Despite these rumors, local blacks attended the barbecue and heard speeches from prominent candidates, including Attorney General John W.A. Sanford and U.S. senator James L. Pugh.[82] The informal, communal nature of barbecues allowed former slaves access to high-ranking national and state politicians.

By 1874, Democrats had regained control of power on the state and local levels, leaving the Republican Party consisting almost exclusively of African Americans. Despite these facts, some African Americans, as they had done before, broke ranks and sought out alliances with Democrats in hopes of improving their situation.

In the 1876 election in Leighton, eighty African Americans voted for Democrats and attended a barbecue held in their honor. "In appreciation of this fact," explained a reporter, "the white Democrats of that locality collected a large sum of money, got up a magnificent barbecue and extended special invitations to the faithful fourscore and their families." During the meal, black and white speakers addressed the biracial audience, which consisted of equal numbers of black and white people. Afterward, everyone had eaten what they could "with an occasional barbecued leg of mutton to carry home."[83] At antebellum barbecues, custom dictated that hosts invited candidates as their guests. In this instance, however, party leaders staged the barbecue to reward voters for their deference and loyalty, signaling a shift back toward a deferential style of politics in which candidates treated voters for their support. As in antebellum days, the hosts barbecued whatever meats they had on hand.

Although black support of southern Democrat politicians seemed to indicate a reconciliation of the races, most African Americans did not support the

Democratic Party, especially on the national level. The Democratic Party had little success winning black votes, in Alabama or elsewhere, until the twentieth century.[84] Instead, the Democratic Party generally treated black Alabamians with hostility. When African Americans participated at political barbecues, they could reasonably expect to encounter some resistance and violence.

In July 1890, fights broke out at barbecues across the state. In Eufaula, Alabama, the political campaign season opened with a barbecue, and the hosts hoped to create a spectacular day "memorable in the history of Caucasian and democratic supremacy."[85] During the festivities, the invited guests confronted an African American who jumped ahead in the food line. According to a local reporter, "They had quite a lively time locking him up, as he fought hard. It took four officers and several citizens to lock him up. They used clubs freely, but that seemed to have little effect on him. He was finally knocked senseless and dragged into the jail."[86]

In Walker County, a barbecue hosted by the local Democrats featured both Democrats and Republicans as speakers, but it also turned violent. When the politicians disputed the division of speaking time, a fight ensued, resulting in thirty gunshots exchanged between the two sides. T.L. Long, a Democrat and candidate for the state legislature, suffered a head injury after a blow from a baseball bat. After the fight, the Republicans refused to participate in the event.[87]

At the end of the century, Alabamians continued to host political barbecues. On July 4, 1896, the Democrats in Alabama hosted a Fourth of July barbecue in Montgomery that included speeches by gubernatorial candidates.[88] In August 1899, two prospective gubernatorial candidates, Judge Jessie Stallings and State Senator Russell Cunningham, spoke at a barbecue in Courtland, Alabama, to an audience of nearly three thousand.[89]

Barbecue and the Black Community in Alabama

After the Civil War and emancipation, African Americans congregated at barbecues in an attempt to help realize their own vision for the New South. As southern states disenfranchised black voters, African Americans had to improve their lives without formal political power. Led by Booker T. Washington, among others, many African Americans worked to uplift themselves and their communities by establishing good schools and strong churches. To these ends, some African Americans turned to barbecue

because of its fundraising potential. Some African Americans, however, resented barbecue because it reminded them of the past, not the future.

Left to fend for themselves, black Alabamians sometimes hosted barbecues to better their lives and realize their vision for the future.[90] Instead of preparing it for their white masters, as they had done during enslavement, African Americans now prepared it for themselves with their own goals in mind. In 1901, black civic leader George M. Newstelle hosted a barbecue for the benefit of black businesses near Montgomery. Newstelle worked with Booker T. Washington in the Negro Business League of Montgomery. In his description of the early days of the Negro Business League, he explained, "We took it upon ourselves to give a barbecue with the two-fold object of increasing our funds and at the same time making an effort to increase our membership." The barbecue was successful. "During the day of the barbecue we not only netted a nice little sum of money, but we also secured quite an addition to the membership of the league," explained Newstelle.[91] For African Americans, barbecue provided a means by which to raise money because it efficiently and effectively attracted and fed large crowds.

Although barbecue proved useful for Newstelle, many African Americans rejected barbecue, especially pork, because of its association with slavery and poverty because of its low cost. Based on this perspective, African Americans aimed to prove their worthiness of citizenship rights by shedding remnants of slave culture, including barbecue and pork. Instead, they adopted manners and habits that would appeal to the white middle class, which included reformers who had new ideas about nutrition and health. Washington ascribed to these ideas and implemented many of them at Tuskegee Institute in Alabama. Although pork was cheap, easy and available for Alabamians to raise and consume, Washington preferred to serve beef at Tuskegee Institute because it suggested refinement and civilization while offering nutrition. At Tuskegee, the cooks served beef in the form of roast beef, veal cutlets, beef stew and similar recipes. They avoided food like barbecue, especially pork, which had previously been prepared by slaves for white masters.[92]

When Washington banned pork from the menu at Tuskegee Institute, he had a vision for the future based on strong black communities. When Newstelle served barbecue to raise funds for his organization, he also looked toward a future of upward mobility.

Barbecue, Southern Nationalism and Reconciliation

As black Alabamians looked to the future at barbecues, white Alabamians viewed barbecue as part of their past, when things had been different. They romanticized barbecue as part of the Old South.[93] At barbecues in post–Civil War Alabama, white Alabamians recalled their past by expressing bitterness over defeat in the Civil War, complaining about race relations during Reconstruction and celebrating southern nationalism. Eventually, they hosted barbecues to reconcile with the North, but not without retaining pride in the South and the cause of the Confederacy.

After the Civil War, white Alabamians hosted barbecues in honor of the defeated Confederacy. In 1880, white southern Democrats gathered in Melvin near the Mississippi border for a barbecue at a place called Kizer Hill. During the barbecue, an unnamed speaker struck a chord with the audience by proclaiming, "The Confederacy still exists, my friends, and Jeff Davis, the best friend we ever had, is yet our President and devoted to our interests." He pleaded, "You must stand by the great Democratic Party, for a solid South will now give us entire control of the General Government and we can redress all our wrongs."[94] When Greenback Party politician J.H. Randall attempted to speak, the speaker cried, "We don't want any damned Yankee to come here and talk to us. We had better shut him up." Finally, Randall had an opportunity to speak to his southern audience, but a brass band from nearby Shubuta drowned him out.

As wounds healed, Alabamians reconciled with the nation and with their former enemies at barbecues. On July 4, 1879, five thousand former Confederates gathered in Montgomery for a celebration and "old-fashioned barbecue." A minister paid tribute to the "wisdom and patriots of the men of 1776" yet emphasized that southerners should forever "cherish the principles for which their forefathers contended." The event featured speakers from the South, but northerners had a presence, as well. On behalf of Union generals Winfield Hancock and George McClellan, speakers read aloud letters that the northern generals had penned for the occasion.[95]

By the end of the century, white Alabamians increasingly undertook extensive efforts to inscribe the landscape with monuments to the Confederacy and seek out former comrades, perhaps for the final time. In Alabama, barbecues became a major feature of the various reunions and memorialization efforts of the Confederate veterans and the United Daughters of the Confederacy.

In 1899, Confederate veterans from Alabama gathered in Opelika for a reunion and barbecue. There, they fraternized with old comrades and listened to civic leaders while partaking in the free barbecue. The speakers, which included Congressman Jesse Stallings and future Alabama governor William J. Samford, addressed an audience of more than two thousand people.[96]

Alabamians hosted barbecues to raise money for a variety of causes, including the Lost Cause. In Eufaula, Stella Guice, who served as the president of the Barbour County chapter of the United Daughters of the Confederacy, led the effort to erect a Confederate monument. Beginning in 1897, Guice hosted barbecues at her family's plantation on the Chattahoochee River to raise the $3,000 necessary to purchase the granite monument.[97] On November 24, 1904, the women completed their work. "It was a red-letter day for the good people of Barbour County," reported a writer for *Confederate Veteran*, a magazine dedicated to the memory of the Confederacy. Before the unveiling, ten thousand people gathered at the courthouse and processed to the corner of Eufaula Avenue and Broad Street. After prayers and a roll call of Barbour County soldiers and units, Mary Merrill and Ida Pruden unveiled the thirty-five-foot-high granite monument. The polished gray monument features a statue of a Confederate soldier. At the time, spectators considered it "as much a monument to their loving loyalty to the memory of the Confederacy as it was to the courage and devotion of their old comrades."[98]

1891: A Big Barbecue Year

Alabamians had a variety of reasons to host and attend barbecues. They often gathered for political purposes or to raise funds or celebrate a holiday, but they did not need these excuses. Sometimes, Alabamians gathered with one another at barbecues to have fun and forget their troubles.

In 1891, hot weather doomed many farmers' prospects for a good year. By mid-August, the *New York Times* reported out of Mobile that "the plants, being very humid, have been scalded by the heat, and the leaves are withering."[99] According to an Alabama correspondent for Nashville's *The American*, hot weather "cost the farmers many hundreds of thousands of dollars" because of its effect on the cotton industry. Due to the weather and crop destruction, "complaint seems more universal than ever."[100]

Despite these circumstances, the farmers "go on and have a good time regardless of bad times." The correspondent from *The American* nicknamed 1891 "The Great Barbecue Year" because "more carcasses have gone into the pot this one summer than were popularly supposed to be on hoof."

The correspondent believed that the barbecues had an ameliorating effect on the farmers, who otherwise might revolt against the Democrats who controlled the state. The correspondent explained that the "mollifying influences of the glorious dinners that have been spread in every country neighborhood" have resulted in members of the Farmers' Alliance remaining in the Democratic Party. The farmers "flout all notion of being driven out."[101] As the economy worsened, barbecue seemed capable of lifting spirits.

When the correspondent nicknamed 1891 "The Great Barbecue Year," he could not have known that another event in the same year would have a profound impact on barbecue in Alabama. In 1891, the Williams family opened Golden Rule Bar-B-Q in Irondale. For more than 125 years, Golden Rule Bar-B-Q has fed hungry Alabamians. Restaurants like Golden Rule Bar-B-Q and many others transformed barbecue in the nation and in Alabama.

CHAPTER 4

DIRT FLOORS AND ROADSIDE SHACKS

The Origins of Alabama Barbecue Restaurants, 1890s–1930s

Around the turn of the twentieth century, Americans moved from the countryside into the city to pursue job opportunities. Among them, African Americans left the farms to seek better lives in the city. At the same time, immigrants poured into the United States and settled in these growing cities as well. By the 1920s, most Americans lived in urban areas. They worked in America's factories, either on the assembly line or as clerks or supervisors, and at other jobs in middle management.[102]

At the same time, Americans fell in love with the automobile. They traveled more often and greater distances for work and leisure. They took advantage of new paved highways to visit previously far-away destinations.[103]

Americans changed their eating habits because of industrialization, urbanization and the invention of the automobile. In previous decades and centuries, restaurateurs catered to the urban elite, who had the disposable income for lavish meals. In each city, wealthy diners only had a few options. After moving from the farm to the city, most Americans now purchased their food rather than cultivating crops or raising livestock. Removed from the dining room table throughout the day, urban workers and highway travelers needed new places to eat their meals. For these reasons, urban residents, workers and travelers generated a concentrated and consistent demand for cheap, quick food. At the turn of the century, restaurateurs opened up cafés, lunchrooms and other quick-service eateries.[104]

In the early twentieth century, barbecue moved from the public picnic table to the restaurant. Throughout the country, barbecue's popularity

and ability to efficiently feed large numbers of people made it a promising business opportunity. In Alabama and elsewhere, barbecue restaurateurs opened stands, shacks and eventually full-service restaurants near urban centers. On highways, gas station managers sometimes sold barbecue in this same manner. Or entrepreneurs sold barbecue out of their homes. These original pit masters only used their barbecue skills to supplement income from another job. They cooked barbecue on Thursdays or Fridays and sold the meat until it ran out; then they repeated the process the following week. Locations on major roads fed travelers; those in urban centers served blue-collar workers, mostly men. If successful, these pit masters sometimes quit their regular jobs and made the barbecue business a full-time endeavor.[105]

Due to the demands of profit, most restaurateurs had to choose simple menus to avoid spoilage and save money, and their decisions led to the regionalization of barbecue. Before the restaurant industry, barbecues consisted of whatever meats the local farmers had to offer. People brought side dishes and desserts based on the ingredients they had on hand and could afford to spare. Restaurateurs, however, had to choose locally available meats that they could sell customers before spoilage took over. In Texas, barbecue restaurateurs chose beef. In North Carolina, they chose pork. In Alabama, they mostly focused on pork and chicken.[106]

Golden Rule Bar-B-Q

The Williams Years of Golden Rule Bar-B-Q

In 1891, the Williams family from Gadsden opened Golden-Rule Bar-B-Q in Irondale, an industrial town outside Birmingham, where Alabamians produced weapons for the Confederacy during the Civil War.[107] At the time of Golden Rule Bar-B-Q's founding, the restaurant sat on a dirt road, but this road eventually became U.S. 78, which served as the major route for travelers between Birmingham and Atlanta.[108]

For more than eighty years, the Williams family operated Golden Rule Bar-B-Q. Until the 1970s, Ellene Williams Stone and Ella Ruth Hutchings Mize managed the restaurant. Ruth's husband, Shorty, worked as a pit man. Ellene's husband, Jabo, worked as an electrician at his family's business, the Stone Electric Company.[109] Although Jabo continued to work as an electrician after marrying Ellene, he pitched in to help at the restaurant on

Golden Rule Bar-B-Q in Irondale now has a prime location immediately off I-20. *Author's collection.*

the busiest days. As an owner of the restaurant, he also negotiated the sale of the restaurant in later years.[110]

For most of the twentieth century, Golden Rule Bar-B-Q served breakfast and barbecue pork plates, hamburgers, hamburger steaks, hot dogs, French fries and salads but also cigarettes and beer. Sometimes, they also repaired automobiles.[111] Under the ownership of the Williams family, Golden Rule Bar-B-Q did a lot of business in barbecue but especially in beer. For many years, travelers had to purchase alcohol in Irondale because only dry counties lay between them and Atlanta. People on the outskirts of the city had to come to Irondale to imbibe.[112]

Golden Rule Bar-B-Q earned a reputation in Birmingham for excellent food. As a young man, Michael Matsos, who eventually owned numerous restaurants and hotels in Birmingham, including Golden Rule Bar-B-Q, had visited the restaurant as a patron and eaten the barbecue sandwich. "I used to go to the Golden Rule," said Matsos. He recalled gathering with friends "just to get some good barbecue." He added, "I loved their barbecue sandwich the way he [Shorty Mize] did it and everything and the sauce."[113]

Until the 1960s, Golden Rule Bar-B-Q had a segregated dining room, as required by Alabama state law. When Matsos visited the restaurant as a

young customer, he remembered the presence of segregation. He explained, "They had a separate dining room in the back for the blacks with their own jukebox." He added, "I wasn't used to that, being from up North."[114] In 1964, however, the U.S. Congress passed the Civil Rights Act of 1964, which outlawed segregation in public establishments.

In 1971, Ellene and Jabo Stone wanted to retire, and they sold the restaurant to Matsos and partner Tommy Stevens. The Stones knew Matsos because of his success in the Birmingham area as a restaurateur. "I think he saw how we were doing at Michael's downtown, and he used to come over there and hang around there," explained Matsos, referring to Jabo Stone.[115]

When Stone sold the business, he did not want any money down but instead wanted royalties. In the sale contract, Stone required Matsos to open another location as part of the deal. "Jabo Stone got the best of me," admitted Matsos. "I think he outsmarted me. I think he made lots more money in twenty years than what he would have got with a cash offer upfront."[116] Under the ownership of Matsos, Golden Rule Bar-B-Q spread throughout the state.

Michael Matsos: An Alabama Restaurant Legend

Born in 1918 in New Bedford, Massachusetts, to Greek immigrants, Matsos lived most of his early life in Brooklyn, New York. Toward the end of the Great Depression, Matsos packed his bags and relocated to Tuscaloosa, where he enrolled in the University of Alabama. "I realized that the University of Alabama Commerce School, at the time, with Dean Bidgood, was the best buy for the money," explained Matsos. He excelled at the university, but his career in business would have to wait a few years.[117]

In 1941, the United States entered World War II. Upon graduation, Matsos recalled, "I got a degree in one hand and a report to Fort Benning in the other." During the war, he enlisted in the U.S. Army Air Corps from Alabama, part of the Fifteenth Air Force in Italy. After the war, he worked as an air traffic controller in Atlanta, Georgia. In 1947, he returned to the Birmingham area, where he entered the restaurant business.[118]

In 1948, Matsos partnered with Greek chef Bill Demoes to open La Paree, which served steaks, seafood and Greek fare to Birmingham's upscale residents and visitors. They opened the restaurant on Fifth Avenue North near the Tutwiler Hotel, where Matsos attracted lots of customers. He

offered free meals to the Tutwiler Hotel's doorman to persuade him to direct hotel guests toward La Paree.[119]

In 1953, Matsos sold his share of the restaurant to Demoes and opened Michael's Sirloin Room in the Holiday Inn in Bessemer, but he soon opened other locations of this restaurant throughout the state. At Michael's Sirloin Room, Matsos served customers many of the same recipes that he had served at La Paree. Later in the 1950s, Matsos opened new locations in the Holiday Inn in Huntsville and the Ramada Inn in Madison. In 1958, Matsos opened another location in the Southside neighborhood of Birmingham near Legion Field. Due to this location's proximity to the stadium, it became a huge success. At this location, Matsos's restaurant hosted many celebrities, including Alabama football coach Paul "Bear" Bryant.[120]

At Michael's Sirloin Room, Matsos partnered with some of Birmingham's future chefs and restaurateurs, thus making an imprint on Birmingham food that has continued after his death. In addition to the restaurants, Matsos owned Birmingham's Hyatt Regency, where Frank Stitt worked as a beverage director. Stitt has become an internationally famous chef and winner of numerous James Beard Foundation Awards. He now operates Highlands Bar and Grill, among other Birmingham favorites, such as Chez Fonfon, Bottega and Bottega Café.[121]

Two Greek men who have partnered with Matsos have gone on to own and operate some of Birmingham's other favorite restaurants. In the 1980s, George Sarris from Tsitalia, Greece, founded the Fish Market, which sells fresh fish as well as Greek-inspired seafood dishes. Connie Kanakis, who partnered with Matsos at Michael's Sirloin Room, also partnered with Matsos to open Rossi's Italian.[122]

Birmingham has many Greek restaurateurs, including many of them in the barbecue business, but Matsos believes he became one of the best because of his university training. "They were dedicated, and they were willing to work," commented Matsos, explaining why Greeks in Birmingham had an affinity for the food industry. Like him, these Greek restaurateurs benefited from a Greek lineage that emphasized quality food. Matsos explained, "They understood cooking because it was sort of handed down from their grandmothers and mothers and so forth, and they kept the recipes. Up to this day, some of the recipes are really hard to beat." Unlike them, Matsos had a business degree. "I had an edge on them because I was a university graduate and I understood the business sense," he explained.[123]

Sammy Derzis and Michael Booker

In 1974, Matsos and his business partner, Stevens, needed a manager for the Irondale location of Golden Rule Bar-B-Q. Sammy Derzis took the job, where he has remained and become a partner in the business. "Tommy Stevens and I grew up together. We were best friends," Derzis explained.[124]

Born in Birmingham's Norwood neighborhood, Derzis has Greek ancestry and has worked in the restaurant industry since his youth. His maternal and paternal grandparents came from Sparta, Greece, and immigrated to the United States. His mother, Kay, came from Chicago. His father, Gregory, worked in the restaurant industry as a partner in two restaurants: Knotty Pine and Jeb's Seafood House.[125] At these restaurants, Derzis got his start cleaning floors and busing tables. "When you got old enough to go to work, you went

When Michael Matsos purchased Golden Rule Bar-B-Q, he hired Sammy Derzis to work as the restaurant's manager. Derzis now owns a share of the business. *Author's collection.*

to work," explained Derzis, in the matter-of-fact way that people of Greek descent approach their work.

After attending Jacksonville State University, Derzis joined the navy and traveled around the world. From 1968 to 1972, he visited Cuba and the Mediterranean on the destroyer USS *Allen M. Sumner*. After a brief stint working for the Social Security Administration, he left government work and found a home in the restaurant industry. He simply stated, "I was tired of government work."

Upon quitting government work, Derzis went to work at Joe Namath's Restaurant before joining the team at Golden Rule Bar-B-Q. In its heyday, Joe Namath's Restaurant attracted top musical acts, such as B.B. King, Fats Domino, Jerry Lee Lewis and other performers. "They needed a bartender, so I became their bar manager," explained Derzis.[126] At Joe Namath's Restaurant, Derzis met cook Michael Booker.

For about four decades, Michael Booker has worked as the pit master at Golden Rule Bar-B-Q in Irondale. *Author's collection.*

Born in Evergreen, Alabama, Booker attended Ramsay High School in Birmingham. As a high school student, Booker cooked steaks at Joe Namath's Restaurant. After graduation, he joined the army and served eight years as a cook in Germany. "I kept in touch with Sammy when I was in the military," explained Booker.[127]

When Golden Rule Bar-B-Q needed a new pit man, Derzis reached out to Booker. After Booker joined the staff, he learned how to cook barbecue from Pancho Simms, one of the pit masters who had worked for the Williams family and continued to work there after the restaurant changed ownership. "He took the time with me because he saw that I wanted to learn....It was a different experience than cooking steaks," explained Booker, who had to transition to cooking pork.[128]

Although Golden Rule Bar-B-Q has expanded across the state, the management and staff still view the restaurant as a family. In fact, Simms's cousin Deborah also worked at the restaurant as an expeditor, keeping cooks and wait staff on the same page and ensuring food moves from the kitchen to the tables in a timely manner. At Golden Rule Bar-B-Q, Booker met Deborah, and they hit it off, married and started a family. "These are some great people to work for," he said. "I go to their homes on holidays, and that means a lot."[129]

The New Golden Rule Bar-B-Q

The cooks at Golden Rule Bar-B-Q prepare custom-made sandwiches. They will mix inside and outside meat to your preference. *Author's collection.*

Once a small restaurant on a dirt road, Golden Rule Bar-B-Q has become regionally famous and recognized as one of the oldest operating restaurants in America. Under the ownership of Stevens and Matsos, Golden Rule Bar-B-Q has expanded in terms of menu offerings and locations.

In the mid-1970s, Matsos and Stevens relocated the site of the restaurant and changed its atmosphere. They moved the restaurant to its current location just off I-20. Matsos explained, "I was lucky enough to get the piece of property right across the street from the exit."[130] In the new location, the management wanted a different vibe. "We wanted to present more of a family atmosphere," explained Derzis, commenting on the decision made by the owners. The management of Golden Rule Bar-B-Q moved away from alcoholic beverages and put more emphasis on food.[131] Over the last thirty to forty years, many barbecue restaurateurs who also owned restaurants on major highways between large cities made the same decision to focus on food.

With a renewed emphasis on quality food, Matsos believed strongly in keeping the kitchen area in the center of the restaurant, just like it had been at the old location. Matsos explained, "One of the things I kept up was having the pit in the dining room, where the customers see that it's fresh—that there's nothing hidden in the back." They do all the cooking and carving in the center of the restaurant, where every customer can watch. "The only thing in the back of the house is the dishwashing machine and maybe some prep area of getting things ready," boasted Matsos.[132]

In the early hours of the morning, employees put the pork shoulders in a smoker. At daybreak, Booker comes to work and removes the meat from the smoker and finishes it on a pit. Matsos explained, "We start it in the smoker because with the smoker you sort of are cooking from the inside out." This way, the meat reaches perfect doneness.[133]

When Michael Matsos took over the restaurant, he moved it to this location off I-20. *Author's collection.*

Then, the cooks carve each sandwich to order. Matsos boasted, "We make a custom-made sandwich." They prepare each sandwich with sliced or chopped inside meat, outside meat or a mixture, according to customers' wishes. "We have customers that are more or less spoiled," remarked Matsos.

When the sandwich arrives on the plate, it has many things in common with other pork sandwiches in the Birmingham area: a red, tomato-based sauce and sliced pickles. Matsos explained, "Our sauce is the main thing, too, because ours is a tomato-based sauce, and people like it in this area."[134]

Over the years, the new ownership team made many changes to the menu. Golden Rule Bar-B-Q now sells barbecue chickens, loin back ribs, turkey sandwiches, beef brisket, baked beans, French fries, potato salad, barbecue salads, green beans and more. In addition to these various offerings, Golden Rule Bar-B sells fresh pies, such as lemon icebox and coconut, and banana pudding.[135]

The Next Generation

In 2009, the Matsos family sold ownership of Golden Rule Bar-B-Q to Jeff Miller. At the time, Miller owned hundreds of Lee's and Mrs. Winner's chicken restaurants. As part of the deal, the Matsos family had

franchisee ownership of four Golden Rule Bar-B-Q locations, including the one in Irondale.

In 2012, Michael Matsos passed away. By the time he had reached the age of ninety-three, Matsos had served celebrities like Bob Hope and Charles Barkley at his numerous restaurants throughout the city and state. "He constantly amazed me with his business sense and leadership ability," explained Derzis, who also described Matsos as an expert deal-maker.[136]

Despite Matsos's death, Golden Rule Bar-B-Q continues to have a strong influence from the past. Every day, Booker and Derzis work at the Irondale location. Together, they have more than seventy years of experience in the barbecue industry. The Matsos family, led by Michael's son Charles and daughter Michele, continue to own Golden Rule Bar-B-Q restaurants.[137]

Big Bob Gibson Bar-B-Q

The Origins of Big Bob Gibson

In the early 1920s, railroad worker Bob Gibson began a side business selling barbecue on the weekends from his backyard off Danville Road in Decatur. Gibson, who stood six feet four inches tall and weighed more than three

The Gibson family poses with the barbecue in Big Bob Gibson's backyard at his home off Danville Road in Decatur. *Chris Lilly.*

Catherine McLemore, a daughter of Big Bob Gibson, poses with her son, Don, outside their home off Danville Road in Decatur, Alabama. Big Bob Gibson got his start cooking barbecue in the backyard of this home. *Chris Lilly.*

Big Bob Gibson poses with his barbecue and white bread at a park in Decatur. *Chris Lilly.*

hundred pounds, was popularly known by the nickname "Big Bob." "He still was working for the railroad when he started barbecuing and kind of did that as a past-time in the backyard, but people seemed to like his food so well he decided to quit the railroad business," explained Gibson's grandson Don McLemore, who continues to help run the business.[138]

After leaving his job on the railroad, Gibson cooperated with his brother-in-law, Sam Woodall, to open a restaurant on Moulton Road in Decatur called Gib-All's. Woodall left the partnership to join his brother in business, and Gibson continued the operation under the now-famous name Big Bob Gibson Bar-B-Q. Gibson relocated his restaurant numerous times in the 1920s and 1930s. McLemore described the early restaurants as places where "you might stand up and place an order and might have a few chairs or stools or something."[139]

As the business grew, it became a family endeavor. On the subject of family, McLemore recalled, "They all had an interest in the barbecue business. They all did go in the barbecue business, and that's how they made their living— all of them."[140] Gibson's restaurant rose from these humble origins to gain regional and national recognition due to his original white sauce recipe.

The Invention of White Sauce

Gibson crafted a vinegar-based white sauce to smother his smoked chickens. He split his chickens, seasoned them, roasted them over hickory smoke for three hours and then dunked them in the mayonnaise, vinegar and black pepper concoction. "I guess the thing he's more well known for than anything in the barbecue world is his white sauce," explained McLemore in reference to his grandfather.

Although the sauce was originally intended for chickens, customers now pour it on everything. "They will try it on pork, or some even try it on ribs," explained McLemore. He added, "It's very good on potato chips. A lot of kids do that. I'm not a kid, but I still do it once in a while myself."[141]

Due to the success of the white sauce, it has become a staple of barbecue restaurants across the state. "What makes me feel good is when you go to some of the better-known restaurants in Alabama now, and you see that they have a bottle of white sauce," said McLemore. His son-in-law, Chris Lilly, also recognizes the importance of white sauce to the state's barbecue scene. "We're most noted for our barbecue chicken with white sauce because it's an original recipe," boasted Lilly. "It's cool to know that there's a regional sauce that gets a lot of publicity, and it started here."[142]

The Next Generations

In 1952, Big Bob relocated the restaurant to an existing building on Sixth Avenue in Decatur, but he also turned the business over to his daughter. Catherine McLemore offered to take over the day-to-day operations of the restaurant in exchange for half the business. Don characterized his grandfather as an outdoors person. "He liked to fish; he liked to hunt," he explained. As part of the deal, therefore, Catherine let her father work as much or as little as he wanted. Don recalled, "He jumped right on it." With a desire to fish more and relax, Big Bob accepted his daughter's offer. Now, Big Bob could spend his time as he pleased.[143]

At the same time, they started selling their mouthwatering coconut cream, lemon icebox and chocolate cream pies. Maddie Johnson, who had started working at Big Bob Gibson's Bar-B-Q in the 1940s, made the pies when Catherine added them to the menu. She continued to make pie for five decades. According to current owner Chris Lilly, "At Big Bob Gibson's, the

At Orange Lake near Gainesville, Florida, Big Bob Gibson shows off his catch. *Chris Lilly.*

In 1952, Big Bob Gibson opened this location of his restaurant on Highway 31 in Decatur. It remained in operation until 1987. At that time, the family constructed their own building on the adjacent property. *Chris Lilly.*

Inside the Highway 31 location of Big Bob Gibson Bar-B-Q in Decatur, a waitress serves a packed house. *Chris Lilly.*

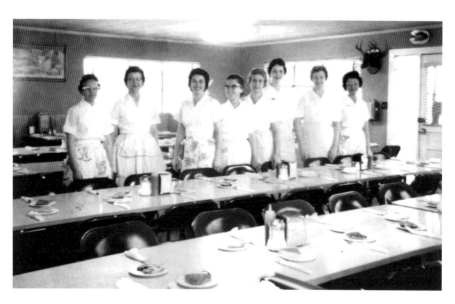

On the far right, Maddie Johnson poses with the rest of the Big Bob Gibson Bar-B-Q staff. In 1947, Johnson started working for Big Bob Gibson Bar-B-Q and remained employed there for many decades. *Chris Lilly.*

pie makers open the restaurant. They get here before the pit guys." Recently, they have added pecan and peanut butter pies.

After Gibson's death in 1972, his five grandchildren, including Don, and their spouses took over the business. Under new ownership, Big Bob Gibson Bar-B-Q relocated one more time and opened a second location. In 1987, they built a larger restaurant on Sixth Avenue because their previous landlords refused to allow them to remodel and expand the existing structure. In 1992, they opened a restaurant on Danville Road. These two locations remain open for business.

They also modernized the facilities. Originally, Big Bob smoked the meat, which he purchased from local farmers, in an "old-fashioned concrete block pit." His family has since modernized their methods for the sake of commercial feasibility and safety, but Don insisted, "we come as close as we can" to cooking meat in that traditional manner. "We still have the old-fashioned brick pits—not concrete blocks but brick and firebrick. We have a flat grate and we have a big fire up in the front of the pit, and we cook with indirect heat and smoke."[144]

When Gibson opened his first restaurant, he served pork shoulders, chickens, coleslaw and potato chips, but the menu has continued to expand

Before the restaurant opens, Diane Wilhite and D make pies every day for the large crowds who pack Big Bob Gibson Bar-B-Q. *Author's collection.*

Like the other pie makers at Big Bob Gibson Bar-B-Q, Joanne Gunner arrives to work before anyone else to make fresh pies for the restaurant. *Author's collection.*

Big Bob Gibson Bar-B-Q offers numerous types of pie, including this coconut cream pie. *Chris Lilly.*

Before Big Bob Gibson Bar-B-Q opens, only the cooks and pie makers have arrived at the restaurant. *Author's collection.*

After the lunch crowd, Big Bob Gibson Bar-B-Q sits quiet before the evening rush hits. *Author's collection.*

Chris Lilly, of Big Bob Gibson Bar-B-Q, surveys the pit room during a quiet part of the day. *Author's collection.*

over the last few decades. In the late 1980s, the menu has expanded to meats like beef brisket and turkey, ribs and more modern dishes like barbecue-stuffed potatoes and barbecue-topped salads, served to an increasingly national and transient audience. "We were the first barbecue restaurant in Alabama, to my knowledge, that started selling the barbecue potato and, at the time, they were cheap to buy because we used the real big potatoes," explained McLemore. These baked potatoes, stuffed with butter, sour cream, chives, bacon, cheese and a choice of barbecued chicken, turkey, pulled pork or beef brisket, soon became a hit throughout the state. McLemore boasted, "Now you can't hardly go to a restaurant in Alabama and not get a barbecue potato."[145]

They cook pork shoulders and beef brisket all night long and carve each sandwich and plate to order. They cook whole pork shoulders, which includes the picnic and the pork butt, for seventeen hours overnight. Big Bob only rubbed his pork shoulders with salt, but they now use a blended dry rub. According to Lilly, "We carve to order, one shoulder at a time." They avoid chopping it ahead of time in order to retain the juices. "If you chop it ahead of time and try to hold it, you need to add a lot of sauces to keep it moist," said Lilly, who now helps run the restaurant.[146]

Mike Wilson, who founded the Saw's family of restaurants, supervises the staff and tastes the product at his Avondale location, Saw's Soul Kitchen. *Author's collection.*

At Big Bob Gibson Bar-B-Q, a pulled pork sandwich comes topped with vinegar-based coleslaw. *Chris Lilly.*

The cooks at Big Bob Gibson Bar-B-Q pull the pork shoulders to order to maintain moisture. *Chris Lilly.*

Big Bob Gibson Bar-B-Q serves turkey platters with two sides and a pickle. Like all their dishes, it does not come with sauce because they want to leave that option to the customer. *Chris Lilly.*

Big Bob Gibson Bar-B-Q serves its turkey on a salad for the health-conscious customer. *Chris Lilly.*

Left: This Big Bob Gibson Bar-B-Q combination platter features pulled pork and smoked chicken, which has been drizzled with white sauce. The sauce, which Big Bob Gibson invented, consists of mayonnaise, vinegar and black pepper. *Ken Hess.*

Right: In addition to their famous smoked chicken and white sauce, Big Bob Gibson offers pork ribs, among other items. *Ken Hess.*

At Big Bob Gibson Bar-B-Q, customers can order beef brisket as well as the pork and chicken that typically feature on the menus of Alabama barbecue restaurants. *Ken Hess.*

Left: Big Bob Gibson Bar-B-Q makes pie every single day, including this chocolate cream pie. *Chris Lilly*.

Below: Every morning, the pie makers open Big Bob Gibson Bar-B-Q to make fresh pie for the day. *Chris Lilly*.

Above: Bob Sykes Bar-B-Q offers customers many choices, including this BarBQ Pork Sandwich. *Elaine Lyda.*

Right: For six decades, Bob, Maxine and Van Sykes have been working in the restaurant industry. *Elaine Lyda.*

Bob Sykes Bar-B-Q slow cooks pork butts over an open pit. *Elaine Lyda.*

Among many sides, Bob Sykes Bar-B-Q offers onion rings. *Elaine Lyda.*

In addition to pork sandwiches, Bob Sykes Bar-B-Q offers rib sandwiches. *Elaine Lyda.*

John "Big Daddy" Bishop proudly serves his famous ribs. For a long time, he only served them with white bread. *Dreamland Bar-B-Que.*

At Demetri's BBQ, the pork sandwich is the bestseller. *Sam Nakos.*

Unlike barbecue restaurants in the northern part of the state, Demetri's BBQ serves its chicken with red, tomato-based sauce. *Sam Nakos.*

To complement a diverse menu, Demetri's BBQ has many sides, including green beans, baked beans and fried okra. *Sam Nakos.*

Above: At Golden Rule Bar-B-Q in Irondale, pork slowly cooks over an open pit. *Author's collection.*

Right: Originally, Dreamland Bar-B-Que only sold ribs and white bread. Now, they have pulled pork, sausages and more. *Dreamland Bar-B-Que.*

When John "Big Daddy" Bishop opened the restaurant, he did not have pork sandwiches or side items. As the restaurant expanded, they needed more options to reach a wider audience. *Dreamland Bar-B-Que.*

In 2006, Dreamland Bar-B-Que ran a campaign to posthumously elect John "Big Daddy" Bishop as governor. He ran on the platform of the Dinner Party. Long before barbecue dominated the restaurant scene, Alabamians used barbecue to practice their politics. Today, barbecue remains fundamental to politics. Before the 2016 presidential election, candidate John Kasich visited Dreamland Bar-B-Que in Birmingham. *Dreamland Bar-B-Que.*

Dreamland Bar-B-Que serves world-famous ribs with their famous sauce. *Dreamland Bar-B-Que.*

Above: At Moe's
Original BBQ,
they do more than
barbecue. They serve
catfish and shrimp
po' boys, as well.
Mike Fernandez.

Left: Moe's Original
BBQ serves their
chickens and turkeys
with white sauce.
Mike Fernandez.

Right: Moe's founders Ben Gilbert, Mike Fernandez and Jeff Kennedy all come from Alabama, but they started their first restaurant in Vail, Colorado. *Mike Fernandez.*

Below: The smoked chicken sandwich comes topped with coleslaw. *Mike Fernandez.*

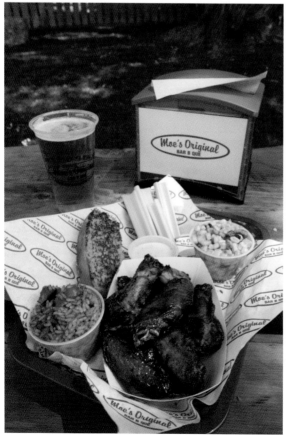

Above: At Moe's Original BBQ, the rib platter comes with sides and a drink. *Mike Fernandez.*

Left: The smoked wings platter comes with white sauce and side items. *Mike Fernandez.*

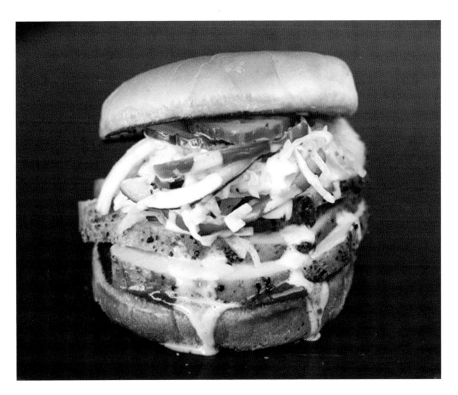

Above: Libby Fernandez developed the coleslaw recipe that tops this turkey sandwich. *Mike Fernandez.*

Below: In recent years, Bob Sykes Bar-B-Q has expanded its dessert menu to include cakes. *Elaine Lyda.*

Above: Bob Sykes Bar-B-Q bottles and sells its original sauce. Many of Alabama's barbecue restaurants aspire to sell their own sauce across the state and the country. *Elaine Lyda.*

Below: In Bessemer, Van Sykes tends the pit at Bob Sykes Bar-B-Q. *Elaine Lyda.*

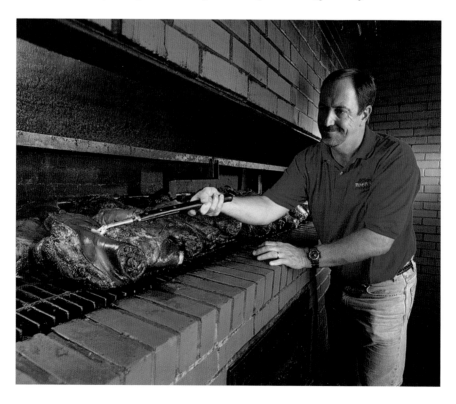

In the morning, they start cooking chicken, ribs and turkey. They procure all of their American-raised meat from purveyors in Birmingham, Huntsville and just across the border in Tennessee. "I think you are doing yourself a great disservice if you limit yourself to one meat supplier," explained Lilly. Before ordering, he surveys the meat for price, color and marbelization to make the best choice.

Big Bob Gibson Bar-B-Q Ribs
Cooking Method: indirect heat
Suggested Wood: hickory
Cook time: 4 hours

2 slabs St. Louis cut pork spare ribs

Dry Rub
2 tablespoons brown sugar
1 tablespoon paprika
1 ½ teaspoons kosher salt
1 teaspoon black pepper
½ teaspoon garlic salt
½ teaspoon onion salt
¼ teaspoon celery salt
½ teaspoon red pepper
½ teaspoon ground cumin

1 bottle Big Bob Gibson Championship Red Sauce

Remove the membrane from the back of the rib. In a small bowl, combine the dry rub ingredients and mix well. Apply generously to the front and back of ribs, patting gently to ensure the rub adheres.

Build a fire (wood or combination of charcoal and wood) for indirect cooking by situating the coals on only one side of the grill, leaving the other side void. Preheat charcoal cooker to 250 degrees Fahrenheit. Place the ribs on the grill meat side up and cook with indirect heat for 3 hours 45 minutes or until the ribs are tender.

Remove ribs from cooker and paint with Big Bob Gibson Championship Red Sauce. Put the ribs back on the cooker over indirect heat and cook until the sauce caramelizes, 10 to 15 minutes. Remove the ribs from the grill and let them rest for 10 minutes before serving.

Like other Alabama barbecue restaurants, Big Bob Gibson Bar-B-Q uses hickory wood to build its fires. According to Lilly, "The most important aspect of wood is how long it's seasoned. It's more important than the variety of wood. When you get a nice seasoned wood, you get a mellow smoke and a great smoky flavor." The seasoning process consists of drying the wood to the desired moisture content. At Big Bob Gibson Bar-B-Q, they use hickory wood that has been seasoned for four to six months.[147]

Over the years, Big Bob Gibson Bar-B-Q has left an impression on more than just the Alabama barbecue scene. Recently, it has attained international fame because of the success of Chris Lilly at international barbecue cook-offs.

Chris Lilly Joins the Family Business

Born in 1968 in Florence, Chris Lilly learned to appreciate food, especially barbecue, from his parents, but he never envisioned becoming the owner of a barbecue restaurant and world champion pit master. "My family sat down for dinner every night and ate as a family. I had a good hot meal every night and enjoyed food," recalled Chris.[148]

Like most Alabamians, Chris fondly remembers his father, Owen Lilly Jr., cooking barbecue in the backyard. Whenever his father cooked outside, he wanted to help. As a child, Chris experimented with marinades and seasonings. "Growing up, cooking is something I always liked to do, but I never thought it would turn into a profession." He admitted, "I never dreamed I would be in the barbecue business."[149]

In addition to backyard cooking, Owen took his large family to some of Alabama's famous barbecue restaurants. "My dad loved barbecue. I still remember going around to the barbecue restaurants with the old pit masters shoveling coals under the pit," Chris recalled. Growing up in Florence, Chris enjoyed pork sandwiches at locally famous Bunyan's Bar-B-Que, located on West College Street not far from McFarland Park on the Tennessee River, and Dick Howell's Barbeque Pit, which remains in the same cinderblock restaurant that Chris's father helped build.[150]

Owen, who grew up in Memphis and studied architecture at Georgia Tech in Atlanta, had fond memories of Big Bob. To get to Atlanta from Memphis, Owen traveled through Decatur and would stop and eat at Big Bob Gibson Bar-B-Q. By this time, Gibson had a full-service restaurant. Chris explains, "My father remembered seeing Big Bob behind the counter

handing out bubblegum to the kids and putting on a big show." Many years later, Chris met Big Bob's great-granddaughter Amy McLemore.[151]

From 1986 to 1990, Chris studied marketing and finance at the University of North Alabama, where he met Amy. On September 1, 1990, Amy and Chris married, which brought Chris into the family business. Lilly says, "I was very fortunate. When I got into the barbecue business, I started with what I thought was the best barbecue. Big Bob Gibson's Bar-B-Q already had a great history and a fantastic reputation in this area." Lilly adds, "I think one of the best things I have done is take that reputation and let everybody know about it. Now, Big Bob Gibson's Bar-B-Q is known around the world." Lilly appreciates the restaurant's global recognition. "When you look at the license plates, you see so many different license plates from outside of Alabama. These are people who have come to eat here."[152] Lilly has helped spread the reputation of Big Bob Gibson Bar-B-Q through his team's success at barbecue competitions.[153]

The Competition Scene

After joining the restaurant, Lilly has helped Big Bob Gibson Bar-B-Q achieve international fame by leading his crew to victory at numerous international barbecue competitions. Barbecue competitions come in many different formats. They all have rules concerning team composition, fuel source, the use of electronics and recipe restrictions. In Kansas City Barbeque Society competitions, teams submit samples to judges in four categories: chicken, pork ribs, pork and beef brisket.[154]

For more than forty years, the Memphis in May World Championship Barbecue Cooking Contest has attracted the best competitors from around the world. At Memphis in May, Lilly has led the Big Bob Gibson team to numerous titles. They have won the grand championship at this famous competition four times: 2000, 2003, 2011 and 2014. In addition to these grand championship titles, they have also won eight times in the pork shoulder category: 1999, 2000, 2001, 2002, 2003, 2004, 2011 and 2014.[155]

Due to competition success, Lilly has changed some of the recipes at Big Bob Gibson Bar-B-Q. "We have used the competitions as marketing research for our restaurant," explained Lilly. Before the competition scene, they only used salt, black pepper and cayenne pepper. Now, they have unique dry rubs for each of their meats. Lilly explains, "All of those recipes were born through competition." They do not change the recipe at the restaurant solely

In 2000, Don McLemore, Chris Lilly and the rest of the Big Bob Gibson crew first won grand champion at Memphis in May International Festival. *Chris Lilly.*

because of competition success. Lilly tests these recipes with loyal customers. He explained, "We have a lot of regular customers who have eaten here their entire lives." He added, "We wanted their blessing before we rolled it out in the restaurant."[156]

They have also added a new sauce because of its success at barbecue competitions. Big Bob Gibson's Bar-B-Q still offers the original white sauce recipe crafted by Big Bob. For years, they also had a traditional sweet red barbecue sauce. They bought it on the market and bottled it. "I never liked it; Don never liked it," explained Lilly. When they started doing competitions, they wanted to formulate their own sauce. Don and Chris exchanged recipes and ideas over and over again. According to Lilly, "We traded it back and forth for a year and half." In 1997, their wives had grown tired of the guys messing up the kitchens at home, and McLemore and Lilly decided to finish the recipe. They mixed their two best recipes, entered it into the sauce contest at Memphis in May and won. Now, they serve the sauce in their restaurant.

The Future

Chris and Amy now have three children: Jacob, Andrew and Caroline. The two boys have already started in the family business. Jacob and Andrew both graduated from the University of Alabama, and they help their father run Big Bob Gibson Bar-B-Q. After working for a year elsewhere, Jacob returned to Decatur and started working at the restaurant's location on Sixth Avenue. Andrew returned to Decatur immediately and works at the Danville Road location. "I started them where I started: in the pit room. You have to learn

Jacob Lilly, like his father before him, learns to master the pit before taking on any other responsibilities. Jacob, who graduated from the University of Alabama, represents the fifth generation of the family to work at Big Bob Gibson Bar-B-Q. *Author's collection.*

the pit room and how to cook everything before you can learn the rest of the restaurant," explained Lilly.[157]

The team at Big Bob Gibson expresses enormous respect for barbecue restaurateurs in the state of Alabama. "I have a lot of respect for the family-owned restaurants who have been doing it decade after decade and pass the traditions down," explained Lilly.[158]

Chris Lilly wants Alabama barbecue to become recognized for its barbecue success. He explains, "Often, I think Alabama has been overlooked. People shoehorn barbecue into four regions: Kansas City, Carolina, Memphis, and Texas....I think we've helped push Alabama barbecue to the forefront."[159]

DREAMS AND OPPORTUNITIES

Black Barbecue Entrepreneurs in the Civil Rights Era, 1940–1970

I n the mid-twentieth century, African Americans had limited opportunities available to them in the United States, especially in the Jim Crow South. They suffered from discrimination in hiring practices and earned lower wages for their work than their white counterparts. They tended to work the lowest-paid and most grueling jobs, often under the supervision of white employers and overseers. They rarely had union protection. When businesses cut costs, they often fired black workers first.[160]

In the food preparation industry, African Americans rarely fared much better. During enslavement, African Americans had done a large part of the cooking for white slaveholders. After emancipation, black women often found work in domestic service and continued to prepare food for white families. In the twentieth century, African Americans cooked for white customers in white-owned restaurants that they themselves could not visit as dining guests because of segregation laws.[161]

As consumers, African Americans did not have equal access to restaurants in the Jim Crow South. Due to their exclusion from these public spaces, African Americans often made restaurants the focus of their civil rights work. Most famously, they used sit-ins at southern lunch counters, where black activists endured verbal and physical assault and humiliation in pursuit of their rights. They perceived access to restaurants and diners, just like the voting booths, as a right of citizenship.[162]

In the segregated South, African Americans made spaces for themselves where they could cook for and associate with one another. In restaurants,

taverns and juke joints, and other black-owned spaces, African Americans enjoyed a measure of freedom unavailable to them in other public spaces.[163] Nonetheless, segregation meant that African Americans did not have the same mobility and choice as white Americans.

In 1964, President Lyndon B. Johnson signed the Civil Rights Act, which came under immediate scrutiny from white Alabama restaurateurs. After the passage of the law, the Birmingham Restaurant Association (BRA) challenged it. Congress based its authority to pass the law on its constitutional power to regulate interstate commerce. The BRA used Ollie's Barbecue as its test case. They wanted to prove that Congress had no right to legislate on the issue of segregation.

For decades, the restaurant's owner, James "Ollie" McClung, had sold barbecue out of a makeshift stand on Green Springs Highway in Birmingham. In 1927, he opened a permanent restaurant. Traditionally, Ollie's only served white customers in the dining room and made African Americans, who almost exclusively populated the neighborhood, take their orders home with them. Although McClung would not serve African Americans in the dining room, he employed a primarily black staff—about 66 percent of Ollie's employees were African American.[164]

In December 1964, the Supreme Court upheld the Civil Rights Act by ruling in *Katzenback v. McClung* that discrimination at Ollie's Bar-B-Q affected interstate commerce because it restricted the mobility and economic opportunity of African Americans. The Supreme Court also pointed out that McClung purchased almost half of his food from out-of-state suppliers while undoubtedly pursuing "a policy against serving Negroes."[165] After the decision, McClung grudgingly desegregated his restaurant and served five African Americans a few days after the decision. After desegregation, Ollie's Barbecue continued to serve diners for more than thirty years. In 2001, the restaurant closed, but Alabamians can still find its sauce at local grocery stores.[166]

Before the passage of the Civil Rights Act of 1964, black men and women started their own restaurants using the skills they had developed over centuries of cooking food for white families. There, they tended to serve black and white customers. In addition to these jobs, some black women earned extra income by selling food as street vendors.[167] Despite the difficult work, long hours and razor-thin margins associated with restaurant ownership, black families started some of Alabama's most notable barbecue restaurants. By operating any type of restaurant, including a barbecue restaurant, black Alabamians pursued economic independence and financial security. After desegregation, black-owned barbecue restaurants continued to serve clients of all races.[168]

Brenda's Bar-B-Que Pit

In the middle of World War II, James and Jereline Bethune opened the Siesta Club in Montgomery, Alabama. At first, they operated it as a nightclub that also sold food. Eventually, they changed it from a nightclub to a barbecue restaurant, which they named after one of their daughters.[169]

Since 1942, Brenda's Bar-B-Que has remained in the Bethune family. In 1956, James passed away, but Jereline and her family continued to operate Brenda's Bar-B-Que Pit for many decades. When Jereline passed away, her sons Milton and Larry took over the restaurant. In 2014, Milton died, and Larry assumed sole ownership. Currently, he employs many of his family members, including his daughter Donetta. As Larry works in the kitchen, Donetta performs a variety of tasks, including meal prep and customer service.[170] As a family and restaurateurs, the Bethunes endured many struggles but continued to operate their little restaurant.

The Bethunes started their restaurant in the middle of World War II, a global event that provided fertile ground for the growth of the civil rights movement. During World War II, African Americans flocked to the National Association for the Advancement of Colored People (NAACP) and formed new organizations, such as the Congress for Racial Equality. Inspired by the Double V campaign, which referred to victory on behalf of democracy at home and abroad, African Americans launched a movement for civil rights that continued for twenty years and beyond. Having fought and died for democracy in Europe, African Americans increasingly demanded protection of their political and civil rights at home.

The Bethune family has played an active role in the work for civil rights. According to Larry Bethune in an interview with food columnist Jim Shahin, "My mother and my sister and my auntie would help the NAACP." They used their restaurant's printer to create flyers about upcoming NAACP meetings. Their restaurant also offered a measure of security because of a fence that helped them hide their civil rights work from the Ku Klux Klan.[171]

In the 1940s through 1960s and beyond, the Bethune family endured many hardships, often on account of their race. According to Donetta Bethune, her grandmother overcame many obstacles as a black female barbecue restaurateur. She told interviewer Matt Omarkus, "There was a lot of discrimination, especially with inspections." Despite these obstacles, Jereline successfully managed the restaurant. When Jereline faced a difficult inspection report, Donetta explained, "she would do everything that was

Since 1942, Brenda's Bar-B-Que Pit, opened by Larry James and Jereline Bethune, has offered take-out barbecue to hungry customers in Montgomery. Now, Larry Bethune owns and manages the restaurant, which also employs his daughter, Donetta Bethune. *Author's collection.*

asked and then she would come in and be asked to do something else."[172] As times have changed, the Bethunes have remained committed to their little restaurant.

Brenda's Bar-B-Que Pit consists simply of an ordering window and small kitchen. It has no dine-in space, so customers must take their orders with them. It sits among a plethora of empty and run-down buildings. Despite the economic circumstances of the neighborhood, Brenda's Bar-B-Que Pit continues to thrive. "We've had tremendous support from the community," Donetta boasted.[173]

In recent years, Montgomery has started to turn a corner with economic development in downtown and eastern neighborhoods, but the western part of the city, where Brenda's continues to operate, has not necessarily seen these improvements. "It has been primarily west Montgomery that has supported us," said Donetta. However, Brenda's smoky chicken and juicy ribs inspire long-term loyalty in customers. "Even those who used to live here, they still come to eat here. And they pass the word along."[174] Brenda's Bar-B-Que Pit's success proves that Alabamians will seek out good food and come back for more.

Brenda's Bar-B-Que Pit has become locally famous for its ribs, but it has success with most of its menu. James Bethune boasted, "People really seem to like our chopped pork, and our fried fish."[175] For side items, they have coleslaw, beans, potato salad and French fries. They also serve dessert, such as sweet potato pie. In addition to these conventional options, customers can also order pigs' ears. During enslavement and later as sharecroppers, African Americans often made delicacies out of the cheapest cuts of meat, such as the ears, jowls, tongues, necks and hooves.[176] At Brenda's Bar-B-Que Pit, the pig's ears come on white bread with mustard. Donetta claims they are the second-best seller on the menu, behind the ribs.[177]

Customers can find Brenda's Bar-B-Que pit just a half mile down the road from City of St. Jude Catholic Church, a place with historic importance in the civil rights movement. On March 24, 1965, civil rights activists camped at St. Jude before finishing their march from Selma to Montgomery. On March 25, Martin Luther King and thousands of other activists completed their five-day, fifty-four-mile march with a demonstration at the Alabama capitol building.

Lannie's Bar-B-Que Spot

Before the Selma to Montgomery marchers set out from Brown Chapel African Methodist Episcopal across the Edmund Pettus Bridge on the Montgomery Highway, they enjoyed meals from Lannie's Bar-B-Que Spot. At the time, Lannie's Bar-B-Que Spot had not yet achieved fame across the state and region.[178]

In the 1940s, Will Travis Sr. and his wife, Lannie, opened the restaurant together on Minter Avenue. Prior to entering the barbecue business, Will worked at a baseball bat factory. "He always loved cooking," said their granddaughter Caroline Hickman.[179] According to Lannie's daughter, Lulu Hatcher, "My mother used to get hogs and my stepfather would kill them. She would cook the meat on top of the stove, and then put it in the oven to bake and sell."[180]

When the family moved into their current building, Will built a pit outside and barbecued the meat. "He knew exactly what he was doing," said Lannie's grandson Sam Hatcher. He cooked the meat on an open pit over hickory wood. They blended new and seasoned hickory to get the perfect flavor and heat.[181]

In 1946, Lannie and Will Travis started Lannie's Bar-B-Q Spot, which has been in operation ever since and employed multiple generations of the family, among others. *Author's collection.*

When Will and Lannie operated the restaurant, they only sold barbecue prepared on an open pit, but the younger generations have modernized the cooking techniques and expanded the menu. When the restaurant opened, Lannie's sold every part of the pig, but they currently prepare only ribs and whole shoulders. They have abandoned the open pit for a gas rotisserie, which uses a smoke box to add flavor. In addition to barbecue, Lannie's currently sells burgers, wings, fish sandwiches, shrimp, bologna and chicken nuggets. For side items, they offer fried okra, fries, onion rings and corn nuggets.[182]

Although some things have changed, Lannie's continues to honor the past in their food and work ethic. As they have always done, they still include a piece of crackling on their pork sandwiches. They also have their own tomato-based sauce. "The sauce really makes everything blend together," explained Sam Hatcher.

More importantly, according to Sam Hatcher, the crew at Lannie's Bar-B-Que Spot knows how to treat customers with respect. "The way we were raised, we know how to treat people." Everyone leaves Lannie's sated with good food and good company. Keeping the joint a family business means that employees represent not only the restaurant but also the family name, a responsibility they take seriously.[183]

Lannie's Bar-B-Que Spot has remained in the family for more than seventy years. In 1972, Will passed away. As of 2016, Lulu Hatcher owns the restaurant, which employs mostly family, including Lulu's daughter, Deborah. Generally, family members start working at the restaurant at a young age making sandwiches and wrapping them up for customers. Soon, they take on more responsibility. "By the age of twelve, I was running it," explained Hickman. She explained that the family did not put pressure on her to join the family business but asserted that she never seriously considered anything else. "It was my choice," she said.[184]

In its seven decades of operation, Lannie's Bar-B-Que Spot has often been involved in the civil rights movement. When it first opened, the family served both black and white customers, even though African Americans could not visit white-operated restaurants. In an interview with Jim Shahin, Deborah explained the forms of harassment they endured. She said, "This was a mean, cruel place back in those days." She recalled the Ku Klux Klan causing trouble in their neighborhood in Selma. "We would go in the house and turn the lights out."[185]

When people gathered in Selma for civil rights work, the employees at Lannie's Bar-B-Que Spot took food to them. In an article on black barbecue restaurateurs, Shahin says, "Lannie's is as much a community center as barbecue joint."[186] In 1965, civil rights leaders met at Brown Chapel AME to organize the march from Selma to Montgomery. "When they had the meetings, we used to go down there and feed the people," said Sam Hatcher. He and his siblings and cousins would head down to the church to supply the workers with sandwiches and other food on multiple occasions. "I know I went four or five times myself. They had the meetings every other night," he added.[187]

When the family reflect on the importance of their restaurant, they tend to focus on its impact on the local economy. "It's a good business and people have jobs. It's their livelihood," said Caroline.[188] "It would take the visitors and patrons to tell you anything more," added Sam.[189] Like this family, many African Americans took their skills in making barbecue, often passed down through the generations, and turned them into a path for economic uplift and financial security.

Dreamland Bar-B-Que

Like the Hatchers and Bethunes, John "Big Daddy" Bishop grew up in Jim Crow Alabama and aspired to own his own business. In 1958, he quit his job as a cement finisher and opened Dreamland Bar-B-Que in Tuscaloosa. Amid prevalent racial segregation in the 1950s, Bishop turned his dreams into a successful restaurant, which eventually became one of the most celebrated barbecue restaurants in the state and beyond.[190]

Bishop opened his restaurant because he literally dreamed of a better life.[191] When asked about these dreams, Bishop responded, "One stayed on my mind—was the café—and I'd be talking in my sleep; and I'd be talking in my sleep, you know, in the café. I'd be waitin' on [customers]. So, I decided I'd go into business. I'd try it."[192]

John "Big Daddy" Bishop opened his restaurant, a dream come true. *Dreamland Bar-B-Que.*

When Bishop opened the restaurant, he did not have any training as a cook and tried many things before settling on barbecue. In the beginning, he sold hamburgers and cheeseburgers among other grilled items, but his barbecue was the runaway bestseller. "All the other stuff, I couldn't sell it. Wouldn't do nothin' but throw it out," explained Bishop. "But people wasn't buyin' nothing but my barbecue, that's all they were buyin'." Eventually, Bishop scrapped the other menu items to offer only hickory-smoked pork ribs, served with white bread. At the original location in Tuscaloosa near Skyland Boulevard, Dreamland continues to offer nothing but half slabs and full slabs served with white bread.

Although Bishop's original location remains a small, humble restaurant surrounding a cinderblock pit, Dreamland Bar-B-Que has turned into a regional chain. Bishop's ribs garnered a following that cut across color lines and were especially popular with students at the University of Alabama.[193] Currently, Dreamland has eight locations in Alabama, Georgia and Florida. In addition to these restaurants, Dreamland sells its products online and at Bryant-Denny Stadium in Tuscaloosa and Birmingham's Regions Field.[194]

In 1958, John "Big Daddy" Bishop opened his barbecue restaurant. Although it has expanded across the state and the region, the original Dreamland Bar-B-Que off Skyland Boulevard in Tuscaloosa continues to sell only ribs smothered in their spicy, vinegar-based sauce. *Dreamland Bar-B-Que.*

Among the many students who loved the restaurant, Bobby Underwood took his love for ribs to another level. After working as a dentist, Underwood approached Big Daddy about opening another location. He advised him to talk to his daughter, Jeannette Bishop Hall. In 1993, Hall and Underwood worked together to open a Birmingham franchise of Dreamland. Dreamland has continued to expand its location but also its menu.[195] In 1996, Dreamland opened a location in Mobile, which required an update on the menu. Customers wanted more than ribs, so Dreamland started selling side items like baked beans, coleslaw and potato salad.[196]

In 2000, Underwood's daughter, Betsy McAtee, joined the Dreamland team and rose through the ranks to chief executive officer. Before joining Dreamland, McAtee had experience in a variety of industries. In the 1980s, she studied economics and geology at the University of Alabama. Then, she earned an MBA from the University of West Florida. At first, she worked in retail, selling hosiery. After graduating, she worked at Frito-Lay loading

In 1958, John "Big Daddy" Bishop opened his first café and Paul "Bear" Bryant took over the University of Alabama football team. For more than fifty years, Dreamland Bar-B-Que has only sold ribs at its original location. *Author's collection.*

Located in the Jerusalem Heights neighborhood south of Tuscaloosa's Skyland Avenue near the intersection with Highway 82, Dreamland Bar-B-Que has become a destination for Tuscaloosa's visitors. *Author's collection.*

John "Big Daddy" Bishop poses with his children, John Jr. and Jeannette Bishop-Hall. *Dreamland Bar-B-Que.*

In January 2016, John Bishop Jr., the son of John "Big Daddy" Bishop, poses with his truck and license plate outside the original Dreamland location in Tuscaloosa. *Author's collection.*

and driving trucks. She worked hard, but she still searched for a better opportunity. She explained, "If I got in and learned an industry at the ground level, that would make me more valuable later on." For ten years, she worked at Frito-Lay and reached the position of senior key account manager. In 2000, McAtee joined the team at Dreamland as director of marketing and purchasing. As she did at Frito-Lay, McAtee also gained knowledge of the store by working at the Birmingham restaurant as bar and shift manager. In 2010, she became CEO and has continued to grow the Dreamland brand. In part thanks to her efforts, "you can get Dreamland in more places than you could five years ago."[197]

The Archibalds' Family of Restaurants

In 1962, the African American husband-and-wife tandem George and Betty Archibald opened their restaurant, Archibald's BBQ, in the small town of Northport across the Black Warrior River from Tuscaloosa. They each left working-class jobs to pursue the independent challenge of restaurant ownership. George left Central Foundry steel mill in Holt, and Betty quit her job at a paper mill.

Their children, George Archibald Jr. and Paulette Washington, worked in the restaurant as children and eventually took it over. Before cooking ribs, Archibald Jr. did various chores around the restaurant. "My first job was mopping the floor," he explained. "I started behind the counter when I got about 13 or 14." When he started cooking ribs in his parents' restaurant, he learned the secret to mouthwateringly tender ribs. They told him, "Just take your time with it." Archibald Jr. and Washington assumed control of the restaurant upon their parents' death.[198]

First-time customers often need a bit of help locating Archibald's BBQ at the intersection of Martin Luther King Drive and Tenth Avenue in Northport, but they will definitely remember the route for their inevitable return. By following the scent of hickory smoke that reaches beyond McFarland Boulevard to the north, customers can find the white cinderblock, crimson-trimmed restaurant among lumberyards and cozy houses at the bottom of a hill.

For more than fifty years, Archibald's BBQ has remained in this same building. Inside, there are only a few seats at the counter. From these seats, customers can watch the Archibalds and Washingtons do their work. In a

Since 1962, Archibald's BBQ has been run by the Archibald and Washington families. From this original Northport location, Archibald's BBQ has expanded to include several Archibald and Woodrow's BBQ locations in the Tuscaloosa area. *Author's collection.*

separate dining room, customers can take a seat at one of just a few tables. Outside, customers can enjoy good weather at one of the few picnic tables. Otherwise, they must park their vehicles in the gravel parking lot to pick up their carry-out orders.

For many decades, the restaurant offered a limited menu featuring only sliced pork or slabs of ribs. Archibald's served both choices with white bread and potato chips as the only side items.[199] Under the direction of Paulette's son, Woodrow Washington III, they have added chicken, potato salad and banana pudding to the menu at the original location.

At the original Northport location, Paulette Washington tends to the ribs and pork shoulders in the hickory pit, which serves as the key to the ribs' renowned flavor. "Well the pit's so old, it's seasoned. And we cook it slow," explained Archibald Jr.[200] The ribs have a deep caramel color with a hint of pink just below the surface and a meaty gray center and, although tender, require a determined chew and pull with the teeth to pry them from the bone.

To coat the ribs, Paulette prepares the original vinegar-based sauce developed by her parents. The sauce, according to Archibald Jr., has a tangy

taste and "a little more swing to it" than most places because it uses less tomato.[201] It has an orange appearance with golden specks and adds a bit of kick to the otherwise sweet taste of the pork. After tasting the sauce, it becomes obvious why Archibald's BBQ always provides each customer with an extra container of it alongside three slices of white bread. To take the edge off, customers can choose between bottled Pepsi products or water.[202]

From humble origins, the Archibalds and Washingtons have gained national recognition for their hickory-smoked, open-pit pork ribs. Locally, they pleased the palate of legendary Alabama football coach Paul "Bear" Bryant, who frequently visited to eat his favorite ribs.[203] Nationally, Archibald's ribs finished in the final four of *Good Morning America*'s recent quest to find the best barbecue in the country. "There's nothing complicated about how George makes his barbecue," explained ABC News anchor Ron Claiborne for *Good Morning America*. He added, "He just puts the ribs into the pit. And he smokes them over burning hickory wood."[204]

Across the nation, Archibald's Bar-B-Q has earned recognition from food critics, barbecue enthusiasts and journalists. "If Alabama were a nation," commented a press release from the Southern Foodways Alliance, "the

Woodrow Washington III. *Jim Shahin.*

Woodrow Washington III. *Jim Shahin.*

To expand their presence, Archibald's BBQ now offers catering and even has a Facebook page. Recently, they added a food truck, which serves the University of Alabama campus. *Author's collection.*

national food would be barbecue and the first family would be the Archibalds of Northport."[205] Rather than bask in the fame associated with the family business, Archibald Jr. prefers to focus on the process. When asked about the restaurant, he explained, "Well it's just a small little place." He added, "Just build a fire and keep the fire low, yes—and cook it slow."[206]

In addition to the famous ribs, there's something special that Archibald's Bar-B-Q seems to offer its customers. Despite origins and appearance of their little restaurant, or perhaps due to these characteristics, they have become a model for ambitious barbecue entrepreneurs to emulate. "I took my chefs, local owners, and general managers to Archibald's in Northport," explained Nick Pikahis, who founded Jim 'n Nick's Community Bar-B-Q. He added, "I wanted them to look at the facility and eat the ribs. They have some of the best ribs in the entire country." He continued, "I want my managers and chefs to develop an appreciation for barbecue, and I think they can discover an appreciation for barbecue at Archibald's. It's hard work, so you have to love it."[207]

The Archibald and Washington families have three restaurants in the Tuscaloosa area. They have the original location in Northport founded by George and Betty, but they also have two more restaurants in Tuscaloosa near Skyland Avenue. Paulette's son, Woodrow Washington III, has opened the two newer restaurants called Archibald & Woodrow's BBQ. They have one location on Greensboro Avenue and another on McFarland Avenue, both near Skyland Boulevard. Currently, Woodrow Washington III also serves as a captain of City of Tuscaloosa Fire and Rescue Services and manages all three of the restaurants. The newer locations have an expanded menu, including catfish and many more side items.[208] They have also started to cater special events and operate a food truck near the University of Alabama campus.

An Inclusive Table

Over four centuries, African Americans slowly gained an equal seat at the table. During enslavement, they prepared the food that fed white Americans at political rallies and celebrations of freedom, despite lacking freedom themselves. As the main preparers of the food, they influenced the technique of barbecue preparation as well as its flavor profile, integrating ingredients borrowed from Native Americans, Europeans and their own African cultures.

After emancipation, African Americans continued to make barbecue for white Americans, but they also made it for themselves. They used it to build up their own communities, segregated from the rest of society.

In the mid-twentieth century, however, barbecue became fully inclusive with regard to race. With the passage of the Civil Rights Act, they could visit any barbecue restaurant. African Americans had worked in white-owned barbecue restaurants, but now they started to have places of their own.

The Archibalds, Washingtons, Bethunes and Hatchers have operated barbecue restaurants in Alabama for more than fifty years. They started their restaurants in a golden age of Alabama barbecue, when black- and white-owned barbecue joints started popping up all over the state.

CHAPTER 6

HOG HEAVEN

The Proliferation of Alabama Barbecue Restaurants, 1950–1980

After World War II, many Americans made the jump into the middle class. In 1944, President Franklin D. Roosevelt signed the Servicemen's Readjustment Act, known as the GI Bill. Over ten years, 12.4 million Americans veterans benefited from the GI Bill's programs, specifically tuition assistance for college education. With a college degree, these veterans helped shift the economy from blue-collar manufacturing to white-collar sectors, such as finance and technology. Americans also flocked to defense industry jobs, which remained a vital sector of the economy after World War II because of the emerging Cold War with the Soviet Union.[209]

With these new jobs, Americans moved out of the cities and into the suburbs, creating a boom in the housing market. By the 1950s, a majority of American families owned their own homes. To fill these houses, Americans bought appliances and other consumer goods. Americans had a strong desire to spend their money, thus creating even more jobs.[210]

During the Cold War, Americans improved and expanded their roadways. In 1956, President Dwight D. Eisenhower worked with Congress to pass the National Interstate and Defense Highways Act, which remains the largest public works project in American history and revolutionized American travel. Due to the new legislation, Americans widened existing roads, paved old roads and created the interstate highway system, thus allowing travelers to bypass country highways. As a result, people could travel farther distances commuting to work or for family adventures.[211]

Due to the rise of the middle class and the creation of the highway system, restaurateurs relocated and remodeled their restaurants to attract more customers and updated menus to broaden their appeal. In this era of easy travel and material prosperity, middle-class families more frequently dined out together. Restaurateurs recognized this trend and adapted. They minimized counter service in preference for booths and tables, which improved comfort and facilitated family interaction during the meal. They expanded the menu to include lighter offerings and smaller meals, specifically prepared for children. The postwar change in the economy and demographics affected restaurants around the country, including Alabama's barbecue restaurants.[212]

Alabama's barbecue restaurateurs modernized their establishments by relocating, updating and rebranding. In 1948, for example, Euell Dobbs Sr. moved his restaurant, Dobb's Famous Bar-B-Que, to Dothan to take advantage of the new highway, in this case U.S. 231.[213] Originally, Big Bob Gibson served barbecue from his backyard at a makeshift stand on the side of the road. In 1952, he relocated the restaurant to Sixth Avenue, also known as U.S. Highway 72. At the same time, Gibson expanded the menu, and his successors have continued to change it.[214] When the Williams family opened Golden Rule Bar-B-Q, the restaurant had dirt floors. In 1971, Matsos took over ownership and relocated the restaurant to a spot off I-20.[215] These places, among others, adapted to the new way of things and have continued to serve customers from Alabama and around the world.

From the 1950s to the 1980s, Alabamians enjoyed a golden age of barbecue as new barbecue restaurants opened across the state. In 2015, the Alabama legislature and Governor Robert Bentley wanted to recognize the barbecue restaurants that have served customers for more than fifty years. In conjunction with the Alabama Department of Tourism, they created the Alabama Barbecue Hall of Fame. Of the twenty-nine restaurants that have met the fifty-year requirement, twenty-five opened after World War II. In fact, many of the restaurateurs had served in the military as part of either World War II or the Cold War.

In general, the newer restaurants did not develop the same way as the older places. They did not have dirt floors or makeshift lunch counters. From the beginning, these newer restaurants generally provided full service and expanded menus, which made them palatable to travelers and workers but also middle-class families. The new generation of restaurants benefited from highway and interstate travel. As routes changed, however, some restaurants had to relocate or rebrand as interstates bypassed old country highways.

In every region of Alabama, people can find one of these famous barbecue restaurants within a relatively short drive. They are mostly located immediately off federal and state highways. In 1946, Cotton's Barbecue opened on U.S. Highway 63 between Montgomery and Lake Martin, a favorite destination of swimmers, boaters, campers and golfers.[216] In 1947, Atkin's BBQ opened in Eutaw off U.S. Highway 43. In the 1950s, I-20 became the major route for travelers between Tuscaloosa and Jackson, Mississippi, and Atkin's BBQ sits just off this interstate.[217] In 1949, Johnny Graves opened Johnny's Bar-B-Q not far from U.S. Highway 31 in Cullman between Birmingham and Decatur.[218] In 1958, Rocket Drive Inn, known as the Rocket, opened in Jacksonville on Alabama Highway 21 north of Anniston.[219]

Throughout the state, Alabamians and tourists can find places just like these, with especially high concentrations in Birmingham and the Tennessee River Valley. Of the twenty-nine restaurants in the Alabama Barbecue Hall of Fame, sixteen started in either the Birmingham area or the Tennessee River Valley from Hollywood to the Shoals.

The stories behind these restaurants demonstrate how the war, the rise of the middle class and the highway system have influenced the development of Alabama barbecue.

Birmingham

In 1871, Birmingham became a city and attracted corporate investment and residents because of the rich mineral deposits of the Jones Valley. Birmingham residents nicknamed their city the "Magic City" because of its unbelievable growth. Within a decade, Birmingham had become an industrial powerhouse in the South as a major center of mining, iron and steel.[220]

After World War II, Birmingham's economy started to change. Now, it serves as the home to the University of Alabama–Birmingham, international corporations, elite hospitals and global banking institutions. As the largest city in the state, Birmingham serves as the home of many of Alabama's oldest barbecue restaurants.[221]

Founded in 1981 by Gus and Maria Kanellis, Costa's barbecue has spread throughout Alabama. As of 2016, Costa's had three locations and sold its sauce on grocery store shelves. Like many of Alabama's barbecue restaurants, the Kanellis family has Greek origins and located their restaurant on a major road in town. *Author's collection.*

In 1953, Johnny Ray and his family started a barbecue franchise. John Simonetti operated the original location on Valley Avenue in Birmingham. Although this location has closed, Johnny Ray's has four locations in the Birmingham area, including this one off Highway 280 in Birmingham. Simonetti opened his restaurant during the golden age of Alabama barbecue. *Author's collection.*

Carlile's Barbecue

In 1945, Warren and Pearl Carlisle opened a restaurant at the corner of Sixth Avenue South and Thirty-Fifth Street in the Avondale neighborhood of Birmingham. When Warren's two brothers, Robert and Herman, joined the business, they built their own restaurant at a new location down the road. They picked a spot just north of Highland Park Golf Course. Together, the Carlisle family operated Carlile's Barbecue.[222]

During World War II, Herman and Warren both served in the military, which led to the strange spelling of the restaurant's name. In official paperwork, a military agent spelled Herman's last name incorrectly as Carlile. The brothers decided to use the incorrect spelling as the restaurant's name.[223]

In the late 1960s, the Carlisles expanded the menu by adding recipes collected from family vacations across the state. For barbecue, the Carlisles served sandwiches and plates of pork, beef and chicken. They smoke their pork for twelve to fourteen hours. To complement the barbecue, they have three house-made sauces. They have an original, vinegar-based sauce but also a sweeter, thicker version, which has more garlic in it. They also have white sauce, the mayonnaise-based sauce created by Big Bob Gibson.[224]

In addition to these items, Carlile's Barbecue offers BLT sandwiches, roast beef, chicken fingers, wings, salads and numerous side items, including fresh-cut French fries, onion rings, baked beans and much more. They also sell desserts, such as cookies, ice cream, peach cobbler and slices of pie. Of these desserts, they consider their fried apple pie, a relatively new addition to the menu, their specialty.[225]

In the 1970s, the Carlisle brothers expanded their presence by opening up a new location in Scottsboro. They situated the restaurant on U.S. Highway 72, which connects the cities of Huntsville and Chattanooga. The new restaurant, called Carlile's Restaurant, has a similar menu as the original Birmingham location.[226]

In 2007, the Collat family bought Carlile's Barbecue in Birmingham and have worked to modernize the restaurant while staying true to the Carlisle way. The Collat family owns and operates Mayer Electric Supply Company, one of the largest businesses in the Birmingham area. They want to use the same principles developed at Mayer to run their new restaurant: keep it simple. According to family patriarch Charles Collat Sr., "If Carlile's offers quality food, quality service, consistently, people are going to come in regardless. If you don't offer quality products with quality service, consistently, they won't."[227]

The Collat family recognized Carlile's Barbecue's past, but they want to update it for the future. During the decade of Collat ownership, they have added many of the newer items to the menu, including the brisket and fried pies. In the future, they want to operate a food truck. Like most of Alabama's famous barbecue restaurants, the Collats also want to bottle the restaurant's sauce. "Carlile's has been here since 1945. It's an establishment," commented Nancy Collat Goedecke, who works as the CEO of Mayer Electric. Speaking on behalf of her family, she added, "It is one of the best kept secrets in Birmingham, and we want to keep it relevant."[228]

Leo & Susie's Famous Green Top Bar-B-Que

In 1951, Alton and Kenneth Cook opened Green Top Café in Dora, Alabama, just outside Birmingham. At first, they only sold barbecue and burgers to locals and hungry travelers.

The Cooks chose the location to take advantage of the construction of U.S. Highway 78, which connected Birmingham to Memphis. According to Richard Headrick, who eventually owned and operated the restaurant, "There were a lot of establishments already on the old highway because

At Green Top Bar-B-Que, customers can get barbecue sandwiches, among other items, before hitting the road west to Memphis. *Author's collection.*

In 1951, Kenneth and Alton Cook built Green Top Café in Dora on the newly constructed Highway 78. They strategically located the building in Jefferson County so thirsty travelers could get their fix. After Jefferson County, travelers would only find dry counties until Memphis and Mississippi. *Tony Headrick.*

from the Jefferson County and Walker County line to Mississippi and to Tennessee it was dry, and you couldn't get alcoholic beverages." When the new highway opened, Headrick explained, "Green Top Café was the first business on the new highway."[229]

In 1973, Richard's parents, Leo and Susie Headrick, purchased the restaurant from Edith Carey. From 1959 to 1973, Carey had owned the restaurant but did not make many changes to the menu or the service. For these fourteen years, Green Top Café continued to serve burgers and barbecue. After the Headricks bought the restaurant, it has remained in the family.

When Susie found out that her husband, Leo, had purchased the restaurant for $25,000, she recalled, "I thought he was an idiot." Although Susie considered herself a good cook, she never wanted to cook in a restaurant. Leo insisted. During World War II, Leo served in the military but never went abroad. Then, he found work in the coal mines, just like his ancestors. "He was tired of working in the coal mines," explained Susie, who also remembered that Leo intended to buy the restaurant whether she approved or not. "He just thought he'd like a restaurant better than he did working in the mines." So Susie quit her job at the pharmacy and went to work in the restaurant with her husband.[230]

During the 1970s, Green Top Café had a reputation for selling beer and serving a rough crowd, but the Headricks worked to change that reputation. "It was kind of rough, and some people called it a beer joint," recalled Susie. She added, "I never did want them to call it a beer joint." To straighten out rough crowds, Susie kept a big old stick behind the bar.[231]

The customers liked to sing and dance, and Leo liked to join them. "He always sang a lot, especially when he had him several drinks," remembered Susie. Richard recalls, "He was the entertainer of the family."[232] The Green Top Café became a favorite hangout for local college kids. The Headricks

In 1973, Edith Carey sold the restaurant to Leo and Susie Headrick, who were beloved by customers, especially for their impromptu singing and dancing. *Tony Headrick.*

When Leo and Susie Headrick owned Green Top Bar-B-Que, they often held parties. For decades, Green Top Bar-B-Que has been a gathering place for Walker and Jefferson County residents, as well as people from around the world. *Tony Headrick.*

threw parties throughout the year for locals, including a yearly Christmas party for employees and friends.[233]

In 1985, Jackson County changed its laws and allowed the sale of alcohol, so Green Top Café in nearby Walker County calmed down, and the Headricks could finally put more focus on the food. "We still sell alcoholic beverages, but we sell more iced tea than we do that now," explained Susie.[234] According to her son Richard, many people thought Green Top Café would fail after the passage of the new liquor laws in the neighboring county, but the Headricks had no doubt they would succeed. "We knew we had a good product in our barbecue," boasted Richard. He added, "We're more known as a family restaurant. And pretty well that's the way I like it."[235]

The Headricks have expanded the menu as part of their effort to focus on food. "We've added smoked wings, smoked chicken and a few other things," explained Richard's son, Tony. Currently, they have a large menu featuring chicken fingers, salads, baked potatoes and various standard side items. For about a decade, they have also served their smoked chickens with white sauce. They make their salad dressing from scratch.[236]

The Headrick family worked together in the restaurant, which has employed four generations. After the Headricks purchased the restaurant, Leo kept his job at the coal mine for a few years. As a young man, Richard also worked in the coal mines. During the day, Susie and Richard worked the restaurant. After completing the day shift, Richard went to the coal mine. At night, Leo worked in the restaurant after working in the coal mine all day.[237] In 1997, Leo passed away, so Richard stepped up his role in the restaurant. In 2014, Richard passed away. Until Susie died in 2015, she managed the restaurant's money.[238]

Currently, Tony Headrick runs the restaurant with his wife, LeeAnn, and his son, Ricky. "I started here at the age of ten or twelve," explained Tony. "By then, we had gotten rid of the rough element." At first, Tony bused tables and washed dishes. By the time Tony started high school, he had started working in the barbecue pit. "Now, I run the day-to-day operations for two locations," he explained, referring to the original restaurant in Dora and the newer location in Jasper, which opened in June 2014. He has continued to expand the menu by adding some side items, including macaroni and cheese.[239]

Despite the changes, Tony remains true to the open-pit cooking method. They still use indirect heat. "We cook straight off of hickory. We don't cook barbecue in an oven," explained Tony. They cook both whole shoulders and Boston butts, which they chop or slice to order.

Currently, Tony Headrick runs Green Top Bar-B-Que. They have two locations. In addition to the original Dora location, they now operate a restaurant in Jasper. *Author's collection.*

Tony has continued to emphasize the restaurant's food. They make their sauce from scratch. Like most Birmingham-area restaurants, Green Top Café has a tomato-based sauce. "It has a little bit of tang to it. It's not so sweet," explained Tony. Like many Birmingham barbecue joints, the pork sandwiches come topped with pickles.

When the Cooks started the restaurant, they benefited from the opening of Highway 78, but now I-22 runs between Birmingham and Memphis. According to Headrick, "The new corridor took away a lot of the truck traffic." With this in mind, they chose Jasper as the site for their second restaurant. Despite the new interstate, the business has continued to thrive. "We still have a lot of local business," he added. After fifty years in business, Green Top Café has become a destination for many people, not just a pit stop. He explained, "I have a lot of people come in here when they come back to the area for holidays. They need to get their Green Top before heading out."[240]

Top Hat Barbecue

Since 1952, travelers on U.S. Highway 31 connecting Birmingham to Cullman and Decatur have stopped at Top Hat Barbecue in Hayden because of the smell of the smoke from the pit. According to current owner Dale Pettit, the valley's winds carry the smoke in all directions. He boasted, "Hundreds of people over the years have stopped because they smelled the smoke when they went by."[241]

In 1967, Wilbur and Ruth Pettit purchased Top Hat Inn from Arilla Simmons. She knew Wilbur because he worked for the Tip Top Bread Company and sold bread to her. When she wanted to retire, she had many offers for the restaurant, but she called Wilbur and offered it to him because she trusted him. Dale explained, "She had known him for several years and trust is a word that you could use very easily with my father."[242]

When the Pettits took over the restaurant, they wanted to build on the success earned by Simmons. According to Dale, "Mrs. Simmons had a great reputation of serving good food." The Pettits kept most of her original staff, who helped them transition to restaurant ownership.

The Pettits quickly learned how to barbecue. According to Dale, "Neither of them [his parents] knew anything about barbecuing or working with food

At 9:30 a.m. in Blount Springs, the smoke pours out of the chimney at Top Hat Barbecue. The smell of hickory and pork fills the entire valley and serves as the restaurant's only advertising. *Author's collection.*

At lunch, customers enjoy their meals at Top Hat Barbecue in Blount Springs. *Author's collection.*

or anything and had to sort of learn as they went along." They benefited from the expertise of Betty Cooley and Catherine Hoooper, who stayed with the restaurant when it changed hands from Simmons to the Pettit family. They taught Wilbur and Ruth how to cook and much more.[243]

Although the Pettits had the help of former employees, they did not have their son available to help. They purchased the restaurant one month after Dale joined the navy at the height of the Cold War.[244] In the navy, Dale served on destroyers. At one point, he sailed into the Black Sea. "It was pretty scary times. It would be like the Russians getting into Lake Michigan in the middle of the Cold War," he explained.[245]

By 1974, Dale had finished his career in the navy and joined the restaurant with his father. "I had always hoped that he and I could have a business together," he said. They figured out new ways of cooking and developed new recipes, mostly due to Dale's ingenuity. "I have changed most everything," he explained.[246]

When Dale made changes, Wilbur would question him about it, so Dale would have to prove that the new way worked better. "I had to prove it first. Then, he'd take credit for the changes," he joked. Among the changes, he started cooking the whole shoulders from start to finish with the fat on the

bottom near the fire. "It protects the lean side. If it burns, it burns the fat, not the lean meat," he explained.[247]

After one year of working together, Wilbur retired and traveled with Ruth, so Dale took control. For more than forty years, Dale has operated Top Hat Barbecue. He puts a lot of care into every detail and every product. He developed that philosophy as a young man. His family worked as sharecroppers around Blount Springs and Cullman. They grew everything they ate, so Dale continues to emphasize local, quality products.

Dale's attention to detail starts with the wood. He has specific requirements for the wood to burn exactly how he wants it. "I know the wood men who deliver to Dale. If it does not come the way he wants it, they will have to take it back," explained Dale's friend Van Sykes, who owns Bob Sykes Bar-B-Q in Bessemer.[248] At Top Hat Barbecue, Dale uses new hickory, which gives the meat its flavor.[249]

He purchases local, fresh meat. "I try to deal with local people. I could buy foreign fish for half what I pay now," he explained. "People play the pork and fish market like the stock market," he added. With this method, restaurateurs buy meat at low prices and freeze it to use when prices rise. He does not like this method. "My pork was running around a few days ago," he boasted.[250]

Dale Pettit, who arrives at the restaurant at 4:00 a.m. to start cooking barbecue, does not need any instruments to take temperature. He only needs a fork, his sense of touch and his eyes to know when his barbecue has finished cooking to maximum tenderness and taste. *Author's collection.*

After hours of work, Dale Pettit finally removes a pork shoulder from the pit. *Author's collection.*

He carefully tends the meat. He continues to do a majority of the cooking in the pits with the help of an associate. "If I make a mistake, we lose money," he said. The cooking takes between nine and ten hours for the whole shoulders. At Top Hat Barbecue, Dale blends the two parts of the shoulder: the picnic and the Boston butt. This blend gives Top Hat Barbecue a unique flavor because the butt consists of tender meat and the picnic adds juicy, sweet flavor.[251]

Dale takes special pride in his sauce. When Wilbur bought the business, he had to buy the sauce recipe separately. "The original recipe, strangely enough, comes from the Waldorf-Astoria Hotel in New York. I still have it," explained Dale.[252] For a few years, Wilbur and Dale kept tinkering with the sauce, but Dale has not made any changes in more than four decades.[253] Like other Birmingham-area restaurants, Top Hat Barbecue has a tomato-based sauce. Unlike other restaurants, Top Hat Barbecue heats up the sauce before serving to bring out the spices. His daughter Heather Phillips makes the sauce from scratch a few times a week. "There's not a written copy of the recipe anywhere," said Heather. "We keep it very secret because we're proud of it."[254]

In every phase of the business from the pit to the table, Dale cares about quality. On the tables, he insists on providing customers with name-brand condiments, such as Hunt's ketchup. He declared, "If you cut corners, you lose business and lose integrity."[255]

Bob Sykes Bar-B-Q

For forty-nine years, Wilbur Pettit worked for Tip Top Bread Company with his friend Bob Sykes. They delivered bread to the Birmingham area. When the company moved to New York, Bob and Wilbur both needed to find new careers. They both got involved in the restaurant business.[256]

During World War II, Bob and his wife, Maxine, contributed to the war effort. Bob served in the military overseas as part of the U.S. Army Air Corps in Italy and China. Eventually, he became a staff driver. Meanwhile, Maxine worked as a wiring inspector at an aircraft assembly factory in Birmingham and Atlanta. "My mother enjoyed getting a paycheck and working," explained their son, Van. She picked up extra shifts and worked overtime and saved a large sum of money, which she used to purchase and operate a grocery store after the war.[257]

Upon returning home, Bob went back to work at Tip Top, but Maxine lost her job in the defense industry. Like many families in postwar America, they bought a house and a car, so they desperately needed a paycheck to keep their new purchases. Then, Tip Top moved their headquarters to New York City. "I can assure you that my father had no intention of moving to New York," explained Van. Instead, they sold the car and put up the house to secure a lease on a small restaurant.[258]

In 1956, Bob and Maxine leased the Ice Spot, a small restaurant in Birmingham on Fifty-Seventh Street. "They wanted to do something together because they spent the first years of their marriage apart," explained Van.[259] Maxine managed the restaurant. Bob cooked hamburgers and sold milkshakes. "As my mother used to say, 'I was the worker and he was the entertainer,'" he recalled. Maxine took menus to the nearby construction sites to attract business to the restaurant. They also sold T-shirts to help advertise their business. Within a year, they had a loyal following.[260] They soon set out on their own.

Bob had learned to love barbecue from his experiences on the farm in Cumberland City in central Tennessee. On the farm, Buck Hampton, a black man, barbecued hogs for the black sharecroppers. Bob watched Hampton cook barbecue in an earthen pit and became fascinated with the method and the taste. "It stuck with him for the rest of his life," explained Van.

From 1961 to 1964, Bob and Maxine took over a failed barbecue business and operated Bob's Hickory Bar-B-Q near Birmingham's Central Park. They sold breakfast, fish, steaks and more. The Sykeses employed Dot Brown, who cooked. "She worked a lot of the recipes we still have today," explained Van,

Left: At an early age, Van Sykes had already started taking orders at his parents' restaurant. *Elaine Lyda.*

Below: In 1957, Bob and Maxine Sykes opened their first restaurant. They offered curb-side service and a menu of hamburgers and barbecue. *Elaine Lyda.*

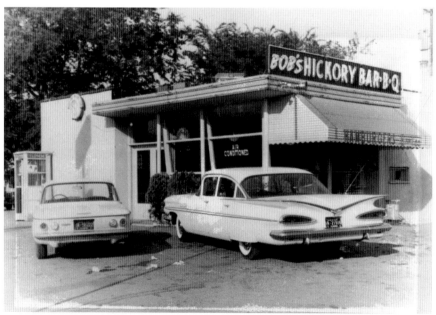

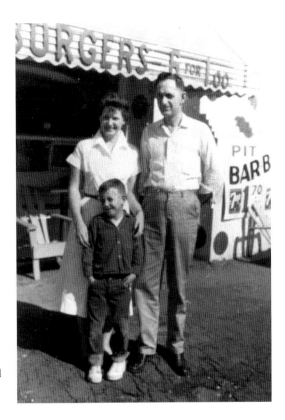

Bob, Maxine and Van Sykes stand proudly outside their restaurant. *Elaine Lyda.*

referring to menu items such as the pies, onion rings, baked beans and more. He added, "She never measured a damn thing. She based it on feel and taste." After a couple years, Maxine pointed out that the restaurant did not have enough money because it had become known as a teenage hangout. They could not shed that reputation, so they sold the restaurant.[261]

For less than a year, Bob and Maxine invested in a root beer business, and Bob also worked at Kentucky Fried Chicken. Maxine had decided that she would never wait tables again. At Kentucky Fried Chicken, Bob learned how to manage a restaurant without wait staff. With a new idea for a restaurant, they looked for a new location. When the owner of local restaurant the Igloo wanted out of the restaurant business, the Sykeses jumped on their chance.

In 1965, Bob and Maxine reopened their barbecue restaurant as Bob Sykes Bar-B-Q in the Five Points West neighborhood of Birmingham. They encouraged people to take their food home to the family dinner table based on the model of KFC. "It was revolutionary at the time," explained Van. Soon, Bob mounted an old radio from a battleship outside, where customers placed their orders. It was the first drive-through restaurant in

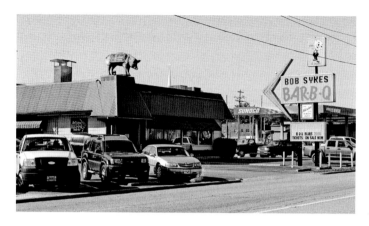

In 1957, Bob and Maxine Sykes opened their first restaurant. Now, their son Van Sykes owns and manages this restaurant in Bessemer. *Author's collection.*

Birmingham.[262] For one year, they ran the restaurant in one of the highest-trafficked areas of the city. Soon, buyers came looking to buy out their lease. In 1966, the Sykeses sold their lease for $80,000.[263]

The Sykeses reopened in Bessemer on U.S. Highway 11. At the time, Highway 11 served as the major connection from Birmingham to Tuscaloosa and Gadsden. "It was the longest lighted highway in the South," described Van.[264] For more than forty years, Bob Sykes Bar-B-Q has remained in Bessemer.

At Bob Sykes Bar-B-Q, customers can choose from a large variety of menu items. They sell pork, beef, ribs and chicken as plates and sandwiches. They also sell chicken filets, hamburger steaks, roast beef, hot dogs, burgers, salads and more.[265]

Bob Sykes Bar-B-Q Southern Coleslaw

⅓ cup heavy mayonnaise
1½ tablespoons tarragon vinegar
1 tablespoon sugar
1 head of cabbage
2 whole carrots

Mix mayonnaise, vinegar and sugar in a large bowl. Add cabbage and carrots; toss to coat. Cover and refrigerate up to 4 hours. Season with salt and pepper to taste. Can add parsley or paprika before serving. Makes 4 servings.

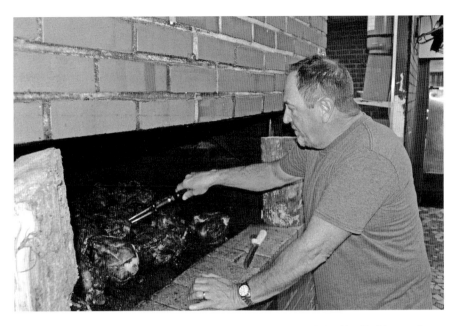

Above: Van Sykes tends to pork butts, which cook on one of Bob Sykes Bar-B-Q's two pits. *Author's collection.*

Below: For twelve years, Martin Vacca Lima has been the pit master at Bob Sykes Bar-B-Q in Bessemer. *Author's collection.*

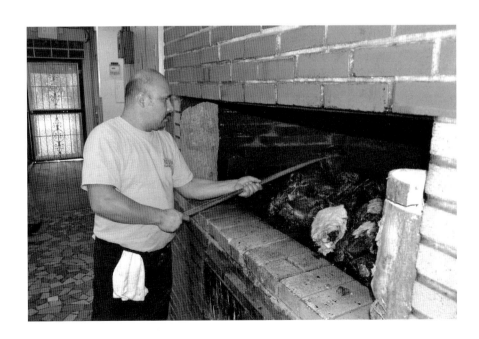

Like most barbecue restaurants, the Sykeses continue to take pride in their original-recipe tomato-based sauce. According to Maxine, her husband could not find a sauce he liked. "We traveled all over Tennessee and tasted every barbecue sauce," she explained. "He would get samples and bring them back to our business and set them up in a jar." Then, customers tasted

Left: In June 2016, Van Sykes presents a check for $2,200 to the Clay House Children's Center, a private nonprofit agency focused on intervention and treatment programs for child abuse victims. *Elaine Lyda.*

Below: Since 2009, Bob Sykes Bar-B-Q has organized and sponsored the Bob Sykes BBQ and Blues Festival in downtown Bessemer. *Author's collection.*

the sauces and voted. Finally, Bob re-created a version of the winning sauce, which they continue to use today.[266]

Since 2009, Van Sykes has hosted the Bob Sykes BBQ and Blues Festival in Bessemer. They have used the festival to raise money for local charities. In the first seven years of the festival, they donated $15,000 to local charities. In 2016, they collected $2,200 for the Clay House Children's Center, a nonprofit child-focused intervention and treatment center for child abuse victims.

Demetri's BBQ

During World War II, Demetrious Nakos, from the Greek island of Corfu, enlisted in the Greek military to fight fascism in Italy and Germany. "He called in air strikes against enemy ships in the harbor," explained his son, Sam. After World War II, Greece broke out in civil war between the Greek government and communist insurgents. In the Greek civil war, Demetrious enlisted on the side of the Greek government, which defeated the communist threat. After the war ended, Demetrious left Greece to join some of his family members in the United States.[267]

Upon arrival in America at the age of twenty-eight, Demetrious worked at Oakland Barbecue, a restaurant in Ensley. His brother owned the property leased by the restaurant. "He started off working at the Oakland Barbecue and got a good taste for the bar business and restaurant business—and barbecue," explained his son Sam, who now owns and runs the business.[268] Oakland Barbecue stayed open late and sold plenty of beer to Birmingham's steel workers. Demetrious wanted to get out of Oakland Barbecue and find work more suitable to family life.

In 1961, Demetrious opened a barbecue restaurant named El Rancho located on Main Street, present-day Eighteenth Street South, in Homewood. At the time, Birmingham did not have the Red Mountain Expressway. Instead, commuters from the southern part of Birmingham had to come right by El Rancho. Travelers from Mountain Brook to Birmingham passed by the restaurant as well. "It was a landmark—a little joint," remembered Sam.[269]

In addition to the commuter traffic, El Rancho also attracted the business of the employees at nearby city hall. Demetrious served many police officers and firefighters. Among them, Captain Al Evans, who eventually became Homewood fire chief, had his construction company build Demetrious a

Since 1972, Demetri's BBQ has served breakfast, lunch and dinner. *Sam Nakos.*

new restaurant. In 1974, Demetrious opened Demetri's BBQ immediately across the street from city hall, where it has remained. At the new restaurant, Demetrious used the same recipes, many of them based on family recipes.[270]

Like Birmingham's other Greek restaurateurs, Demetrious had a knack for the business and especially for cooking. Sam takes pride in the success of the Greek immigrants in Birmingham. "God gave Greeks a palate and I think he also gave them a very, very hard work ethic," he boasted. Among them, he views his father as one of the best. "He had a great palate," declared Sam. "He just had a good cooking ability." In Greece, Demetrious learned how to barbecue lambs. "Barbecue is not unusual in Greece because they cook over open charcoal or open wood," he described. In the United States, Demetrious translated those skills into hickory-smoked pork, chicken and ribs.

The Nakos family worked together in the restaurant. At the age of eight, Sam got his start washing dishes. "On Saturday morning, I would wake up and sit down on the carpet and turn on the television to watch cartoons. I was the happiest kid in the world. Then, the phone would ring. The dishwasher didn't show up," recalled Sam. He added, "I didn't know if the dishwasher actually didn't show up or if my dad wanted me to get to work."[271]

Despite Sam's initial protests, he came to love the restaurant. "I'm glad I paid the price at a young age. Now, I enjoy what my father and I built," he

Demetrious Nakos immigrated to the United States from the Greek island of Corfu, where barbecue has long been a key part of culinary tradition. In this picture, Demetrious poses with his famous lamb roast. *Sam Nakos.*

said. Sam worked alongside his father for decades learning how to manage money, make financial decisions and cook.[272] As a young adult, Sam started cooking in the restaurant, making pies, cutting meat and eventually cooking barbecue.[273]

Under Sam's leadership, Demetri's BBQ has expanded its menu. He added grilled chicken, coconut and chocolate pie, wings, omelets, French toast and more. "We saw the competition on the horizon," he said. To compete, they needed a broader menu.

Serving breakfast, lunch and dinner, Demetri's BBQ has a diverse, award-winning menu. *Sam Nakos.*

Demetri's BBQ has a full breakfast menu. In 2014, *Playboy* honored Demetri's BBQ as the best breakfast in the South and listed them among 101 other fantastic breakfast spots in the country. According to *Playboy* writer Jason Horn, "There's no signature dish or unusual flavor combinations, just the most perfectly prepared omelettes, French toast and pancakes you're apt to find in Alabama." As the best breakfast in the South, Demetri's BBQ beat out many famous restaurants, including Café Du Monde in New Orleans.[274]

Sam has a lot of pride in Greece's food reputation, but he also has an enormous amount of respect for the food scene in Birmingham, especially as it relates to barbecue. "I feel like Birmingham is a very strong area for barbecue," he stated. He added, "We've helped shape and define barbecue for the whole South." He would put Birmingham barbecue up against any region in the country. "I really think we could go to Memphis and show those boys how to do it," he declared. "They have a big national recognition and reputation, but they don't have anything on Birmingham."[275]

Tennessee River Valley

During World War II and the Cold War, Huntsville and the nearby areas of Madison, Athens and Decatur boomed. In 1941, the U.S. Army created Redstone Ordnance Plant in Huntsville, which served as the home to a missile

research program. In 1943, the government renamed the facility Redstone Arsenal. In the 1950s, rocket engineers, including German scientist Wernher von Braun, moved to Huntsville to commence work on the nation's space program. In the 1960s, the government opened the Marshall Space Flight Center, a part of NASA, based out of Redstone Arsenal. There, scientists developed the rockets that took astronauts to the moon. Due to the presence of these government agencies, many defense contractors have relocated to the Huntsville area. It remains a major hub of the technology industry in Alabama. Huntsville also sits on major highways between Nashville, Chattanooga, Memphis and Birmingham.[276]

At the same time, Florence and Muscle Shoals, also known as the Shoals, experienced growth. Before World War II, the Shoals benefited from government investment in the Tennessee Valley Authority. Beginning in 1933, nitrate plants manufactured fertilizer and dams provided electricity to the region. During World War II, the Shoals grew. Among the hundreds of new industries, Wise Alloys produced aluminum for war planes. After the war, the Shoals served as the home for FAME Studios and Muscle Shoals Sound Studio. At these two recording companies, major music stars, including the Rolling Stones, produced countless award-winning and best-selling albums.[277]

From Hollywood to the Shoals, the Tennessee River Valley serves as the home to many of Alabama's oldest barbecue restaurants. After World War II, restaurateurs opened barbecue joints throughout the valley. The barbecue in this region features two notable ingredients: hotslaw and white sauce.

Mud Creek Fishing Camp Restaurant

On the shores of Mud Creek, a section of the Tennessee River in Hollywood, Alabama, Lester Carver owned a fishing camp and boat shop. Lester's business failed, but a new opportunity soon presented itself. In 1946, his son, Bill Carver, completed his wartime naval service and returned home to his wife, Nell. In the same year, the three Carvers founded Mud Creek Fishing Camp Restaurant, which features spectacular waterfront views and excellent food. They also operated a boat shop next door.[278]

The Carver family hired a member of the family, Shorty Bishop, to work as their pit master. During World War II, Bishop had served in the military. In 1944, he returned from the service and became chief of the Scottsboro Volunteer Fire Department. "He learned to cook whole pigs in the ground

Just off U.S. Highway 72 in Jackson County, travelers and sportsmen can find Mud Creek Fishing Camp Restaurant and grab some excellent barbecue. *Author's collection.*

in Hawaii during the war," explained Billy Carver, the third-generation owner of the restaurant. "He created the sauce and the yellow coleslaw."[279] In 1967, Bishop died in an automobile accident with a fellow firefighter on the way to a fire emergency in Hollywood.[280] In the restaurant, Bishop's legacy lives on in the form of these recipes.

Currently, Billy Carver owns and manages the restaurant. He continues to use the same methods used by his parents and grandfather. "We burn hickory down in fifty-five-gallon drums and then use the coals to hickory smoke our meat," explained Carver. They serve chopped butts on a bun with two pickles. They also serve smoked chicken. In the 1980s, the Carvers added fried catfish to the menu, and it has become a customer favorite. Recently, they also added pork ribs. To complement the meat, the Carver family offers two sauces: tangy North Alabama white sauce and a spicy vinegar-based sauce.[281]

At Mud Creek Fishing Camp Restaurant, customers adore the side items. First, most patrons dig into one or two or more baskets of their homemade hush puppies. They come perfectly fried with a balance between light crispness and a touch of greasy goodness. When the meal comes, they have many options for side items, including staples such as French fries. The restaurant features mustard-based coleslaw. This type of coleslaw pops up in the Tennessee River Valley, especially in Florence and Muscle Shoals. In

fact, many restaurants in the region top their barbecue and hot dogs with it. At Mud Creek Fishing Camp Restaurant, the mustard-based slaw comes as a side item. They also offer a pineapple salad, which consists of a pineapple slice, lettuce and mayonnaise. Carver joked, "Our old timers demand it."[282]

Although the restaurant industry has changed, Billy Carver stays true to the original way of doing things. "We're very much a family restaurant and work to be affordable and have a friendly atmosphere," explained Billy. He added, "That's how we've always been."[283]

Dick Howell Barbeque Pit

In 1948, Dick and Amelia Howell, a black couple, opened their own restaurant on North Pine Street in Florence. Like many black restaurateurs in Alabama, they opened their restaurant in a period of segregation. For four generations and more than seventy years, Dick Howell Barbeque Pit has remained in the Howell family. In 2008, Kevin Ingram took over the business that bears his great-grandfather's name.[284]

From the beginning, the Howell family has featured spicy mustard-based slaw in their restaurant. They were the first restaurant in the Shoals to offer it. The mustard in the hotslaw excellently accompanies barbecued pork and ribs but also hot dogs. Unlike Mud Creek Fishing Camp Restaurant, Dick Howell Barbeque Pit serves the hotslaw directly on the sandwiches.[285]

As the owner of the restaurant, Ingram has worked to keep his family's methods intact while adapting to a new era. He continues to cook like his parents and grandparents. He boasted, "I'm still using my great-grandfather's recipes." At Dick Howell Barbeque Pit, Ingram cooks pork over an open pit. He explained, "We cook pork about 16 hours on hand-cut hickory wood." Although the method has remained the same, Ingram has made a few changes. In 2010, he added smoked chicken. Like Decatur's Big Bob Gibson, Ingram smothers his smoked chickens with white sauce.[286]

Ingram would put Alabama barbecue up against any other region's barbecue. In a press conference concerning the Alabama Department of Tourism's Year of Alabama BBQ, Ingram called out barbecue in nearby Memphis. "I feel like Alabama has the best barbecue around if you ask me," he declared. He added, "You always hear about Memphis, well Memphis and Alabama are some of the only places that argue about barbecue. To me, Alabama is the best."[287]

Old Greenbrier Restaurant

In 1952, Jack Webb opened a small restaurant in Madison at the intersection of Old Highway 20 and Greenbrier Road. At the time, Old Highway 20 connected Decatur and Huntsville. Today, I-565 runs nearby.[288] Before the interstate, they saw a lot of car traffic, or potential customers, so musicians performed on the roof to attract people to the restaurant.[289]

Old Greenbrier Restaurant has an extensive menu. They specialize in catfish and barbecue. For barbecue, they offer ribs, pork, chicken and ham. Like Big Bob Gibson Bar-B-Q in nearby Decatur, they serve their chicken with white sauce. Customers can order the barbecue as plates or sandwiches.

In the 1980s, customers could feast on an all-you-can-eat dark meat chicken plate. The first plate of the meal consisted of four chicken quarters. It became a favorite choice of NASA and Redstone Arsenal employees. "We would all order it and pig out," remembered Pat Lewallen, a longtime resident of Huntsville and former employee at NASA.[290]

In 1987, brothers Jerry and Johnny Evans purchased Old Greenbrier Restaurant. Their father, Martin "Buddy" Evans, served as the sheriff of Limestone County. The Evans brothers learned the restaurant industry from their mother, Bobbie Ann Deemer Evans. In 1982, Buddy and Bobbie Ann opened Catfish Inn in Athens, but it has closed.[291]

In Madison, the Evans brothers, Jerry and Johnny, serve smoked chicken with white sauce and many other delicacies, including their locally famous hush puppies. *Author's collection.*

At Old Greenbrier Restaurant, customers start their meal with baskets of their famous hush puppies. Throughout the meal, servers replenish the empty baskets. When Lewallen changed jobs, he took his northern-based clients and co-workers to Old Greenbrier Restaurant to introduce them to proper southern-made hush puppies.[292] "The hush puppies are our trademark," explained Jerry Evans. "People who don't like bread or hush puppies like them. It draws them in." In fact, the cooks could not keep up with demand. "It's impossible to dip as many hush puppies as we need to do," explained Jerry. The Evans brothers looked everywhere for a hush puppy maker. When they finally found a company that made the machines, they made an important business decision. "We wound up buying the company just to keep the hush puppies in business," explained Jerry.[293]

Singleton's Bar-B-Que

In 1957, two brothers, A.L. "Junior" Singleton and Aaron Singleton, opened Singleton's Bar-B-Que on Huntsville Road at the eastern edge of Florence.

Since the age of twelve, Junior's son Rick had worked in the restaurant with his father and uncle Aaron while simultaneously balancing a career in law enforcement. In 1972, he joined the Lauderdale County Sheriff's Department. In 1978, he began working for the Florence Police Department. From 1996 to 2012, he served as the department's chief of police. In 2014, he became sheriff of Lauderdale County, fulfilling one of his lifelong career goals.[294] The restaurant featured memorabilia from Rick's law enforcement career on the walls.

For fifty-eight years, Singleton's Bar-B-Que served barbecued pork and chicken. The pork came with a thin, tangy red sauce. Like most barbecue restaurants in the Tennessee River Valley, the chicken came with white sauce. "The white sauce had a good bite of vinegar," remembered Blake Ball, a native of the Shoals and former student at the University of North Alabama, also located in Florence.[295]

In 2015, Singleton's Bar-B-Que of Florence became one of the inaugural members of the Alabama Barbecue Hall of Fame but also permanently closed its doors. "We knew it had closed, but since it had been around so long, we wanted to honor it," declared Brian Jones of the Alabama Department of Tourism.[296]

With regard to closing the restaurant, Rick explained that it had become too much work combined with his other jobs. He estimated that he worked

between seventy and eighty hours a week at the two jobs in the pit room and in law enforcement. "It will be a little different getting off at 5:00 and going home," joked Rick. When the restaurant announced its closing, people started sharing their memories from first dates to engagement proposals.[297] Rick professed, "We're really proud to be honored, especially for my parents and uncles. They're the ones who really started the business."[298]

Brooks Barbeque

In 1965, an African American couple, Sammie Brooks Sr. and Lucille Brooks, opened Brooks Barbecue in Sheffield near Muscle Shoals in the middle of the civil rights movement. Sammie had served as a cook in the navy. According to his granddaughter Lanndrea Banksden, "He…came up with a lot of different recipes, and it stemmed from there." The family has relocated the restaurant many times. Currently, they have a small, unassuming brick building in Muscle Shoals. Although the location has changed, the recipes remain the same.[299]

For fifty years and three generations, the Brooks family has continued to own and operate the restaurant. Sammie and Lucille had five children, including two daughters, Mary Ann Banksden and Christina Brooks McCants. They run the restaurant with the help of two of their own children, Lanndrea Banksden and Lonzie McCants III.[300]

Inside the restaurant, they only have three tabletops for dine-in customers, so they do most of their business on a carry-out basis. The barbecued meats include pork, chicken, ham, turkey and ribs, which come as sandwiches and plates but also for carry-out by the pound.

Originally, Sammie used an open pit. Now, they cook the meat with a smoker. As the meat smokes, the cooks baste it with Sammie's original basting sauce. "Our basting sauce makes the meat taste special," explained Lanndrea. The meat has a spicy and tangy flavor, complemented perfectly by their famous hotslaw.[301]

At Brooks Barbeque, the sandwiches come topped with homemade hotslaw. The plates come with it, as well, along with homemade baked beans, homemade potato salad and bread. When placing an order, the staff will ask you to choose between regular, hot or mild flavors.[302] They also sell the homemade hotslaw at local grocery stores throughout the Shoals.

In addition to barbecued meat, they serve hot dogs and smoked wings. Like the barbecue sandwiches, the hot dogs come with hotslaw, a match

made in heaven. The wings come in seven different flavors: traditional, lemon pepper, hot, mild, Cajun, hot Cajun and sweet heat.

For dessert, Brooks Barbeque sells sweet potato, pecan and coconut pie either by the slice or the whole pie. Every day, they quickly sell out of these homemade pies originally crafted by Sammie. "I cook the sweet potatoes down from fresh," explained Lanndrea, who now bakes the pies for the restaurant. She boasted, "Nothing is canned. We use all fresh vegetables."[303]

Whitt's Barbecue

In Athens, Alabama, a town just north of Decatur immediately off I-65, Floyd Whitt, who worked as a professional bricklayer, put his skills to use building different types of barbecue pits. He also experimented with different sauce recipes. As neighbors and travelers passed by the house, Floyd let people taste his barbecue and only accepted feedback as a form of payment. After more than a decade of working on the recipe and technique, Floyd and his wife, Laura, perfected their barbecue.[304]

On Labor Day 1966, Whitt's Barbecue opened in Athens.[305] The restaurant did not have any customer seating. Instead, they only served customers through the drive-through lane. Originally, Whitt's Barbecue sat on a dirt road, but that dirt road became East Elm Street, also known as Alabama Highway 99, a four-lane paved highway just off the interstate.[306]

Whitt's Barbecue continues to use the techniques and recipes developed by Floyd and Laura. They only use hickory wood. Unlike many barbecue pit masters, however, Floyd removes the bark, a term for the charred outer pieces of pork. "When we started, we had people say it wasn't real barbecue because it didn't have the hard, gritty pieces in it," explained their son, Joe. The Whitts did not care. "We made barbecue how we liked it, and that's how we make it for our customers."

Over fifty years, Whitt's has gained a regional and national reputation for excellence. According to professional pit master and Athens native Troy Black, "It was a simple, drive-thru-only shack with a limited menu." He added, "A barbecue sandwich consisted of a succulent pulled pork, vinegar-based slaw, a sliced pickle, and mayonnaise." Black's comments about Whitt's appeared in the preface to a book on southern barbecue produced by the editors of *Southern Living*.[307]

Like many barbecue joints, the Whitts keep their sauce a secret, even within the family. As of 2014, only four members of the Whitt family knew

the recipe. The recipe consists of a dry ingredient mix and a liquid mix. According to Joe, "We get a company to mix up the dry ingredients and send it to us. Then we add the liquid ingredients ourselves."[308] This way, they keep the recipe in the family.

The Whitt family has continued to spread Floyd and Laura's barbecue throughout the region. They have thirty-two total locations in Alabama, Tennessee and Kentucky. The Whitt family still owns eight of them. At all the restaurants, they continue to serve things as Floyd did. In fact, new franchisers have to train at the Athens locations. They use hickory wood and offer a vinegar-based sauce. "The pork barbecue, it's cooked the exact same way at every place," said Joe.[309]

An Endless Feast

Birmingham and the Tennessee River Valley have extraordinarily high concentrations of barbecue restaurants, but Alabamians find good barbecue everywhere. Lee Sentell, who directs the Alabama Tourism Department, estimates that Alabama has over three hundred barbecue restaurants, which means a higher percentage of Alabama's restaurants serve barbecue than anywhere else in the country.[310]

In 2015, his department solicited nominations through Facebook for a contest to find the best barbecue in the state. Of these 300 restaurants, more than 180 received nominations.[311] If they had taken nominations with old-fashioned pencil and paper, they likely would have received a nomination for every single barbecue joint in the state. In the state of Alabama, there are too many favorites for one book.

BARBECUE AND BEYOND

Alabama Barbecue Restaurants in the Twenty-First Century

I n the twenty-first century, Alabama's barbecue legends have continued to balance tradition with emerging food trends, such as globalization, organic and heritage-breed food and culinary television and tourism.

For millennia, humans cultivated, sold and consumed local, in-season food, but technological innovations have globalized food production and consumption. Producers and distributors compete in a global marketplace. Restaurateurs analyze the freshness, quality and price of products from around the world. They no longer must rely on local suppliers. They also do not have to schedule their menus based on availability and the time of the year.[312]

With globalization, restaurateurs and consumers now tangle with a host of unprecedented issues. Foreign producers sometimes have stricter or more lenient laws governing food safety and labor practices. As a result, international governing bodies, such as the United Nations and the World Health Organization, have had to deal with the international food trade to ensure food safety and fair labor across international borders.[313] Meanwhile, people debate how the year-round cultivation of food and international trade has affected quality and food safety.

Americans have become increasingly aware of issues pertaining to food safety and quality. The National Organic Program, a division of the U.S. Department of Agriculture's Agricultural Marketing Service, regulates the term "organic" with a strict set of rules concerning production, processing and labeling of food. In 1997, the organic food

industry sold $3.6 billion in food. As of 2008, sales of organic food had risen to $21.1 billion. In fact, organic farmers have trouble keeping up with the demand for organic food.[314]

Likewise, many farmers have started to raise heritage-breed livestock and crops to maintain genetic diversity, thus making animals and plants more disease-resistant. These animals grow at a slower pace than traditional breeds, which means they cost more to raise and cost more for consumers. According to the advocates of heritage breeds, however, the slower growth of these species entails richer, more complex flavors.[315]

Although people have always enjoyed food, it has become a form of entertainment in the television and tourism industries. Currently, Food Network constantly shows programs related to food. On other stations, such as CNN, Travel Channel and major networks, viewers enjoy food-related shows. From 2009 to 2010, TLC aired an original series titled *BBQ Pit Masters*. From 2012 to the present, Destination America has aired new episodes of the program. Through television, some chefs have become international celebrities. People travel all over the world to eat at celebrated restaurants and try unique flavors. In major cities across the United States, tourism agencies offer food-based tours and tastings. In a recent survey, about one-third of travelers admitted to seeking out gourmet food on their journeys.[316]

In the Alabama barbecue scene, restaurateurs have managed these trends in their own way. At Jim 'n Nick's Community Bar-B-Q, Saw's BBQ and Moe's Original BBQ, culinary school–trained chefs developed the menus and recipes. They seek and have won national restaurant awards. Yet they approach barbecue and their menus in different ways from one another when it comes to issues such as globalization and heritage breeds. In the twenty-first century, Alabama's barbecue restaurateurs have forged different paths to regional and national success.

Jim 'n Nick's Community Bar-B-Q

Before Nick Pihakis opened a barbecue restaurant with his father, Jim, he worked at Rossi's, an Italian restaurant in Birmingham owned by fellow Greek Americans Connie Kanakis and Michael Matsos. He worked there for eight years.[317] When Jim retired from the insurance business, he partnered with his son in the restaurant industry. Together, Jim and Nick purchased

an old pizza place, which they owned and operated for three months before closing it down. At this point, they owned a building but did not have a restaurant. With an opportunity to start fresh, father and son chose to pursue barbecue. [318]

In 1985, they started Jim 'n Nick's Community Bar-B-Q. "We chose barbecue because it surrounded us in Birmingham, and we wanted to become part of the Alabama barbecue community," explains the younger Pihakis. Immediately, the Pihakises' restaurant became entangled in Alabama barbecue history. They hired a former pit worker from Ollie's Barbecue to teach them how to work in a hickory pit.[319]

Over the course of nearly thirty years, Jim 'n Nick's has expanded its menu. Initially, Jim 'n Nick's had a limited menu, with pork, chicken and ribs and baked beans, coleslaw and French fries. Now, they serve catfish, which comes grilled or fried. They also offer fried chicken tenders, hickory-grilled chicken breasts and steaks. For barbecue, they feature styles from across the South. They have pulled pork with vinegar-based sauce, like in North Carolina. They also have Texas-style beef brisket. They serve smoked chicken with white sauce, like in the Tennessee River Valley. They even have two styles of ribs: spare ribs and baby back ribs. Although barbecue remains a feature of the restaurant, Pihakis views his chain of restaurants as southern food restaurants, not barbecue joints.[320]

They have continued to expand in terms of their presence, as well. The restaurants have spread throughout the South. As of 2017, the restaurant chain has more than thirty locations in seven mostly southern states: Alabama, Colorado, Florida, Georgia, North Carolina, South Carolina and Tennessee.[321]

At Jim 'n Nick's Community Bar-B-Q, Pihakis has focused on the highest quality, so he hired Drew Robinson as executive chef. Robinson studied at the New England Culinary Institute. After traveling the country, he worked at Highlands Bar and Grill, which frequently wins James Beard Foundation Awards. There, he learned under Chef Frank Stitt and eventually became chef de cuisine, which means he controlled the entire kitchen. Upon joining Jim 'n Nick's, Robinson focused on the careful selection of ingredients and preparing quality southern food.[322]

They prepare everything in the kitchen. "We have always made everything from scratch. We've never had a freezer or pre-purchased anything," advertised Pihakis. In fact, he makes teaching how to cook a major point of the restaurant. He wants his employees to learn a skill and, eventually, take that skill out into the world.[323]

In yet another measure of success, Jim 'n Nick's has won international and local awards. In 2011, Jim 'n Nick's teamed up with the Fatback Collective to compete at the World Championship Barbecue Cooking Contest at Memphis in May. In their first-ever Memphis in May competition, they placed third, which set a record for the best result by a first-time participant. In the same year, Big Bob Gibson Bar-B-Q won the grand championship, which means Alabama placed two competitors in the top three spots. Recently, they have continued to rack up awards. In 2013, Alabama voters selected Jim 'n Nick's as the best barbecue in the state. In 2015, Nick earned recognition from the James Beard Foundation as one of the top restaurateurs in the nation.[324]

Jim 'n Nick's Community Bar-B-Q jockeys for customers with other restaurants, but the communal and familial nature of barbecue tends to overwhelm competitive drive. Pihakis takes his team to visit famous barbecue joints in Alabama and across the South, such as Archibald's Bar-B-Q in Northport. He has a great relationship with other barbecue legends, like the Archibalds and Washingtons. At the Tuscaloosa location of Jim 'n Nick's, Pihakis celebrated George Archibald Jr. and Betty Washington with a dinner in their honor. He says, "Whenever I take a group to visit Archibald's to sample their food, they always tell us to bring some of our food." Pihakis respects the barbecue pit masters of the past because he understands the difficulty of the work. "I want them to know that we love how they work, and I want them to know that we use them as a backbone and inspiration at Jim 'n Nick's."[325]

In this same spirit, Pihakis has emphasized local ownership, promotion from within the company and giving back to local neighborhoods. "We focus on giving back to the community. By growing the business with new locations, we have an opportunity to influence more communities and provide opportunity to more employees," explained Pihakis. Rather than competing with local restaurants, Pihakis has encouraged the development of healthy relationships. "We want to coexist with the restaurants in the cities we have locations. When you view it as competition, you don't get anywhere. You don't learn from each other and nurture each other."[326]

As Jim 'n Nick's Community Bar-B-Q has spread throughout the region, Pihakis has gained more regional and national influence. Pihakis co-founded the Fatback Collective, which has combined the talents and perspectives of farmers, cooks and artisans to celebrate southern food and promote the humane treatment of heritage-breed livestock. "Through the Fatback Collective, we can help each other," says Pihakis. He adds, "Rather

than competing, we often help each other. In fact, we work together on recipes and encourage one another." Of the Fatback Collective's many projects, the Fatback Pig Project promotes heritage-breed pigs and hopes to put farmers back to work.[327]

In the city of Birmingham, Pihakis has promoted healthier, higher-quality foodways. He serves on the board of Jones Valley Teaching Farm, which focuses on educating the Birmingham community about growing healthy produce. Also, Pihakis serves on the board for Pepper Place Farmers' Market, which provides space for hundreds of vendors to sell their produce, baked goods and more.[328]

Moe's Original BBQ

During the golden age of Alabama barbecue, Moses Day made a name for himself in the Tuscaloosa area. Despite the presence of the Archibald family and John "Big Daddy" Bishop in the area, Moe, as they called him, became a Tuscaloosa favorite.[329]

Since the 1950s, Moe, a black man, had supplemented his income from his job at Phifer Wire by cooking around town for Tuscaloosa's upper class and University of Alabama students. He often barbecued meat at Indian Hills Country Club, a favorite golf course of Tuscaloosa's wealthiest and most influential, including football coach Paul "Bear" Bryant. He also cooked at parties around town. When Moe turned up at fraternity parties with his smoker, everyone knew they would have a good time. "He used to cook for people all the time," explained Mike Fernandez, who started a barbecue restaurant chain based on Moe's methods and named in his honor. "He was a guy that everyone in town knew."[330]

In 1988, the Fernandez family went into business with Moe. The Fernandez family ended up in Tuscaloosa because the family patriarch, Dr. Gabriel Fernandez, worked as a neurosurgeon there. Dr. Fernandez had emigrated from Puerto Rico and did his medical training in Birmingham. In 1965, he moved his family to Tuscaloosa. He consulted Coach Bryant's Crimson Tide football team. "My father and Coach Bryant became good friends," explained Mike.[331]

Gabo Fernandez and Moe opened Moe's Original BBQ and Steakhouse on Lurleen Wallace Boulevard in Northport. In 1990, they moved to downtown Tuscaloosa. They leased the Old L&N Train Station on

Greensboro Avenue. "I still love that place," declared Mike. As of 2017, the Old L&N Train Station housed 301 Bistro, Bar and Beer Garden.[332]

In the early years of the business, the Fernandez family knew little about the restaurant business, yet it succeeded because of Moe's name and hard work. "It took off right off the bat," Mike recalled. The entire family played a part in the business. Gabo ran the day-to-day operations. Elizabeth "Libby" Fernandez, the family matriarch, did a lot of the cooking. She baked pies and cooked the side items. Mike added, "We were all trying to figure it out."[333]

Of all the members of the Fernandez family, Mike fell in love with the business the most. As a kid and young man, he loved barbecue. "I grew up going to Archibald's," he remembered. On the way to Lake Lurleen or Lake Tuscaloosa, his family would stop and pick up ribs. "It's always been the same."[334]

Before working at Moe's Original BBQ and Steakhouse, Mike earned his bachelor's degree at Auburn University. Then he went to graduate school in Latin American policy studies at the University of Alabama. He did not finish the program because he preferred to work at the restaurant.[335]

After only a few years in business, Moe grew ill, and the business faded. In 1992, it closed. Mike wanted to remain in the restaurant business, so he went to culinary school at Johnson and Wales University in Colorado. "If I wanted to do this, I needed to learn how to cook," he explained. In culinary school, Mike refined the techniques and recipes taught to him by his mother and Moe. He learned, for example, how to take care of meat before cooking it. He uses salt and brown sugar brines to prepare his chickens for smoking. The chickens soak for twelve to fourteen hours. The wings soak for four to six hours. After cooking meat of any kind, he wraps it in aluminum foil so the steam breaks down connective tissue. "It makes it nice and tender," explained Mike.[336]

After completing culinary school, Fernandez cooked at a large resort in the Rocky Mountains, but he soon brought Moe's Original BBQ back to life in Colorado. He realized that southerners visited the area all the time, but Colorado only had Texas-style barbecue, which emphasizes beef brisket. So Mike teamed up with Alabama natives Jeff Kennedy and Ben Gilbert to bring a taste of Alabama to the resort towns of Colorado. First, they operated a catering business. "We got a barrel smoker from a landlord's junkyard," explained Kennedy in an interview with the *Tuscaloosa News*. In 2002, they purchased a forty-foot trailer, renovated it and sold barbecue in the ski resort town of Vail, Colorado. Within two years, they had a brick-and-mortar restaurant.[337]

Left: Mike Fernandez learned how to cook from Moses Day; his mother, Libby Fernandez; and Johnson and Wales University, a culinary school with a location in Vail, Colorado. After graduation, he worked many jobs before revitalizing Moe's Original BBQ. *Mike Fernandez.*

Right: Jeff Kennedy, Ben Gilbert and Mike Fernandez opened Moe's Original BBQ in Vail, Colorado. They based their recipes and techniques off those of Moses Day, who cooked in Tuscaloosa for many decades. *Mike Fernandez.*

In 2006, the team brought Moe's recipes and techniques back to Alabama. At first, they franchised a series of restaurants along the Gulf Coast. Then, they took on Birmingham. At first, Fernandez hesitated to move his business into Birmingham because of the density of legendary barbecue joints in the city. Nonetheless, they succeeded in Alabama's largest city.[338]

In 2010, Moe's Original BBQ returned home to Tuscaloosa. Just a block away from the Old L&N Train Station, John Moss teamed up with Mike's brother Gabo and franchised a new location of the restaurant. "Mike has been trying to get me back into it, and he finally convinced me," joked Gabo. Moss also opened a location in Auburn.[339]

As of 2017, more than fifty Moe's Original BBQ locations please customers in sixteen states. Every year, Fernandez expects to open five to eight more restaurants. With each new restaurant, Fernandez hopes to get the proprietor up and running as cheaply and quickly as possible. They aim to purchase out-of-business restaurants to keep costs down. Then, they only need to renovate instead of building from scratch. "I think each Moe's is

about the individual owner of each store," explained Mike. In college towns, for example, the owners tend to revolve the restaurant around the bar and live entertainment.[340]

In the risky restaurant industry, Mike has developed a successful business plan. "I buy the cheapest cuts and put a lot of time into cooking it," explained Mike. This philosophy opposes some current trends, such as heritage-breed livestock. "I think there's a place for heritage-breed livestock," admitted Fernandez, but he prefers to put time and effort into turning commodity meat into an excellent product. This way, they keep costs low and help franchisers turn a quicker profit. To these ends, they buy from major distributors like Sysco and U.S. Foods.[341]

From Mike's perspective, Moe's Original BBQ remains true to the traditional methods, just in a different way than places like Jim 'n Nick's Community Bar-B-Q. In earlier centuries, he explains, people barbecued the least-desirable cuts of meat, like the ribs. The technique, not the genetics, made the meat tender.[342]

Mike knows his history. In colonial America, pigs roamed free. They did not spend time in cages, so they would have tasted more like free-range animals today, with less fat content and tougher muscle. These characteristics made them perfectly suitable for the slow cooking of the barbecue pit. Native Americans did not domesticate livestock. They used barbecue to turn the tough meat and tendons of game animals into tender food. For a long time, African Americans could often only afford the cheaper cuts of meat, so they perfected barbecue techniques to create delicacies. At Moe's Original BBQ, they value the technique. Mike declared, "Cooking the meat is our craft here."[343]

Moe's Original BBQ serves barbecued pulled pork, smoked chicken and smoked turkey, plus other southern-style entrees. The barbecue comes either as a sandwich, platter or for carry-out. They pile Libby Fernandez's coleslaw on top of the pulled pork sandwiches, which also have pickles. It also comes with a drizzle of a red, vinegar-based sauce in the style of Archibald's BBQ. The smoked chicken and smoked turkey come topped with this homemade coleslaw as well. The poultry sandwiches and platters come with white sauce. They also offer fried catfish and fried shrimp po'boys. Of all their offerings, the smoked wings have become a customer favorite. They have a crispy, spicy skin and tender, juicy meat.

They serve traditional side items, such as mac and cheese, corn bread, baked beans, chips, potato salad and fries, but they also have daily side specials that rotate with the season. In the summer, they tend to feature

greens and other fresh vegetables. In November, many locations offer corn bread dressing, reminiscent of Thanksgiving. "I got a lot of the style for my sides from my mother," explained Fernandez. "She taught me how to use in-season vegetables."[344] Libby Fernandez's recipes remain on the menu.

Moe's Original BBQ Marinated Slaw Recipe

Marinade
2 cups apple cider vinegar
1 tablespoon mustard powder
1 tablespoon celery seed
1 cup sugar
½ teaspoon salt
1 tablespoon vegetable oil

Bring all of marinade ingredients to a boil, then let cool for a bit before pouring over the slaw mix.

Slaw Mix
1 large green bell pepper
½ large red onion
2 heads of cabbage
2 cups sugar

Method of Preparation
Cut bell pepper and red onion into ¼-inch slices. Core and slice cabbage as thin as you can. Pack ½ of the cabbage into a bowl and add ½ of the bell peppers and red onion. Then sprinkle with 1 cup of sugar and repeat the same process, adding the rest of the cabbage, bell peppers, red onion and sugar. Then pour the room-temperature marinade over the slaw mix. It is best to let it sit overnight, mixed, and then serve.

Many people visit Moe's Original BBQ to drink a bushwacker at the bar. They have spread this Gulf Coast favorite throughout the country. It consists of soft vanilla ice cream, coffee, cacao and coconut liqueurs and rum, blended together in a machine resembling a soft-serve ice cream dispenser.

Mike optimistically views the future of barbecue and southern food. "I'm excited about barbecue because there's so many places opening up," he

said. "Barbecue is king now." He boasts, "Southern food is cool now." He believes that southern food has become popular because of television and the work of the Southern Foodways Alliance, an organization based out of the University of Mississippi with a mission to archive and spread the history of southern food.[345]

At Moe's Original BBQ, they have taken the good news of southern cooking as far north as Maine and as far west as California. He says, "In everything we do, we are trying to sell the South." In fact, he trains his staff to say, "Yes, sir," and "Yes, ma'am" at every location, regardless of region. He concludes, "Barbecue is the South."

Saw's BBQ

Saw's BBQ founder Mike Wilson comes from North Carolina but has roots in Alabama. His family comes from Jasper, Alabama. In 1971, his parents moved to Charlotte, North Carolina, where Wilson was born. At age fifteen, Wilson started cooking at a wine and sandwich shop. Then, he worked at Village Tavern, a chain based out of Winston-Salem, North Carolina, that now has locations throughout the South, including Birmingham. Growing up, Wilson enjoyed Lexington Barbecue, a famous joint in Lexington, North Carolina, which inspires Wilson's menu.[346]

For college, Wilson returned to his parents' home state. In 1991, he enrolled at the University of Alabama. In 1996, he earned a degree in restaurant and hospitality management. After graduation, he went to culinary school at Johnson and Wales University in Vail, Colorado, where he became friends with Mike Fernandez. Although Fernandez remained in Vail, Wilson returned to Charlotte and started cooking at fine dining restaurants, but he constantly experimented with barbecue.[347]

In 2000, Wilson moved to Birmingham and took a job in the test kitchen at *Cooking Light* magazine because he wanted to get out of the restaurant business, but he did not want to stray too far. After work, however, he continued to try out new methods and recipes for his barbecue and sauces. "I learned to barbecue by having a beer and figuring it out," he joked. He created recipes in his home. He added, "I guess it's in my blood. Thank God I wrote down the recipe." To supplement his income, he sold the barbecue to his colleagues at the magazine. He wanted to operate a food truck, but he needed a kitchen in which to prepare the meat. In a whirlwind, Wilson

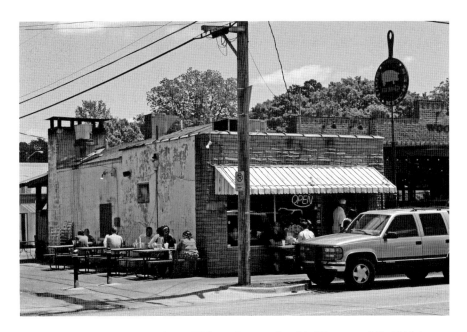

In 2009, Mike Wilson opened Saw's BBQ on Oxmoor Road in Homewood. In 2012, he opened this Avondale location, which sits near Avondale Brewing Company and Wilson's pizza restaurant, Post Office Pies. *Author's collection.*

ended up owning the building previously occupied by Broadway Barbecue in Homewood.[348]

In 2009, Mike Wilson opened Saw's BBQ in Homewood. He had intended on working at *Cooking Light* during the day and at the restaurant at night. For two weeks, he took vacation time at the magazine to set up the restaurant. "I never went back," he said.[349]

Since opening Saw's BBQ, Wilson has continued to expand his presence in Birmingham. In 2011, he opened Saw's Soul Kitchen in Avondale, a favorite neighborhood of Birmingham's young professionals. Coby and Hunter Lake, the owners of the brewery, came to Wilson with an idea. "They wanted me to come and get some food here for the brewery," explained Wilson. They had purchased the building that now houses Wilson's restaurant. Wilson had set his eyes on that building for a long time. "From there, we've grown this neighborhood."[350]

Then, Wilson opened up his pizza joint, Post Office Pies, in the building next door to Saw's Soul Kitchen. Wilson partnered with Chef John Hall for this endeavor. Born in Alabama, Hall worked in New York City with Chef David Chang. Then, he returned to his home state to work at Post Office

Pies. The restaurant, situated in an old post office, has quickly earned a national reputation for excellence. Of all the wood-fired pizzas, the Swine Pie has a loyal following. It features pepperoni, homemade sausage and thick pieces of bacon.[351]

Due to the presence of the brewery and the two restaurants, Avondale has become a major sensation with Birmingham's young adults. The brewery features a large open-air beer garden with yard games and food trucks. They allow patrons to bring in food to the brewery and the beer garden. On beautiful days, Birmingham residents flock to enjoy good food from Wilson's restaurants on the grounds of the brewery. It has become almost a ritual to visit Avondale to celebrate the end of winter and the arrival of spring.

In 2012, Wilson opened Saw's Juke Joint in Crestline with partners Doug Smith and 2006 *American Idol* winner and Birmingham native Taylor Hicks. This location features live entertainment, including blues and jazz artists. Wilson and his partners wanted to create this restaurant because they consider music and barbecue a perfect match.[352]

Between Wilson and Hall, the Saw's team has plenty of culinary expertise. They both worked at fine dining establishments, but they wanted a different experience. "You can get good food without all of the stuffiness," explained Wilson. "We wanted good food and good times without the hassle."[353]

At each of Wilson's restaurants, the team prepares a different menu, but they serve barbecue at all the restaurants. They smoke pork for twelve hours to make the pork plates and sandwiches, which come with a vinegar-based sauce reminiscent of Wilson's home state of North Carolina. "It's old-fashioned barbecue pulled to order," says Wilson. They also have smoked chickens and smoked wings drizzled with white sauce, in honor of Wilson's new home of Alabama. They also have barbecued ribs and a variety of barbecue-stuffed potatoes. They feature traditional side items, such as fries, baked beans, green beans and coleslaw, as well as southern favorites, like fried green tomatoes, fried pickles, deviled eggs and corn. "We keep it seasonal and keep it fresh," said Wilson. In summers, they tend to emphasize tomatoes, watermelons, corn on the cob and Cullman County strawberries. In the winter, they have sweet potato pies and squashes.[354]

At Saw's Soul Kitchen and Saw's Juke Joint, they serve these barbecued items plus so much more. They offer burgers, fried chicken sandwiches and shrimp and grits. Customers rave about the fried green tomato BLT and the pork and greens. "It looks like a hole in the wall, and they have the standard foods, but they're innovative," says longtime Avondale resident David McRae. He added, "My favorite food is grits and greens with barbecue pork."[355]

Wilson takes enormous pride in his craft. He appreciates that customers spend their hard-earned money on the food created by his staff. He says, "I created this food with my hands, and it's an honor if someone wants to come and eat it." He commanded his staff, "If you're not going to serve that plate to your mother, don't serve it to my guests." He puts an enormous amount of pressure on himself. "My competition is me," he said. "I would love to win a James Beard Award for regional food. That's my goal."[356]

A BLAST FROM THE PAST

Alabama Barbecue Clubs

At barbecue gatherings in by-gone eras, people probably didn't need a reason to be reminded to get together and share each other's time. That's just not the case anymore. People look for reasons to maintain community and their sense of place in it. Fortunately, we have barbecue as a sort of communal elixir.
—*Drew Robinson, executive chef at Jim 'n Nick's Community Bar-B-Q*[357]

After the Civil War, Alabamians revived scenes of antebellum barbecues by making barbecues a fundamental element of their club meetings. Dating back to 1872, the exclusive Montgomery Gun Club, which consisted of the wealthiest (white) members of the state, held an annual shooting contest. Along with the shooting contest and officer elections, the club members provided "an abundant and delicious barbecue" for family and friends.[358] In 1897, Alabama's State Bar Association met for an annual meeting, elections and "an elegant barbecue dinner" with "an abundance of cooling beverages."[359]

For centuries, barbecue has remained one of the best ways to attract and feed a large crowd. In most parts of the state, Alabamians do not tend to barbecue whole hogs as a regular occurrence, except in West Alabama, where residents still enjoy barbecue feasts reminiscent of past centuries.

In 1927, Sumter County's men congregated in a fraternal organization housed in a small shack to play cards and engage in other gambling activities, and they often made barbecue as part of their gatherings. Out of these club meetings, West Alabama's barbecue-specific clubs emerged.[360]

CONCLUSION

In Sumter County, seven communities have started formal barbecue clubs, and they each have distinct methods and recipes. The Timilichee BBQ Club members in Geiger continue to cook whole hogs in their pit. In the Emelle Club, members prepare pork butts and pork ribs, which they serve with their Brant Richardson barbecue sauce, named after its creator.[361]

Barbecue clubs have rejected store-bought sauces and instead smother their pork with special recipes that members pass on to younger generations. "Like the wine regions of France, each club has a subtly different sauce," explained author Laura J. Axelrod. At Epes BBQ Club gatherings, which occur monthly from April through October each year, Mr. Bud makes the sauce. "His sauce is so popular that he makes it for people in and around the Epes community," explained a member of the club.[362]

At old-time barbecues, farmers brought whatever they could spare to the community barbecue and shared with one another. To this day, Sumter County's barbecue clubs rely on community assistance for side dishes and desserts, with preference for coleslaw, potato salad, baked beans, cookies, cakes and pies.[363]

In West Alabama, the clubs remain an important part of community formation and development in a sparsely populated, rural area. The clubs generally gather once a month from spring to autumn for their feasts. "It's a sacramental supper that ties together neighbors and generations," observed Axelrod. Gump Ozment of the Sumterville Club explains, "In the country, the only time you see folks is when you go to church, go to a funeral, or go to a barbecue club."[364]

In the antebellum South, people hosted barbecues to raise funds for local needs, and the barbecue clubs continue to perform these civic functions. They tend to meet in local community centers, such as schools and churches. The clubs will host dinners to benefit local facilities. The Panola BBQ Club, for example, consists of members from the local Methodist church. They use the funds raised from their events to support the church. The club, which started in 1946, raised funds for new Sunday school facilities by cooking two hogs and serving them to church members, and it has since become a tradition. Now, the club cooks six hogs each year in an open pit filled with hickory coals. Before closing, the Cuba BBQ Club members hosted their events to raise money for local schools.[365]

Originally, these clubs had strict membership requirements, but they have followed twentieth-century trends toward inclusivity. The Timilichee BBQ Club and the Emelle BBQ Club initially consisted entirely of men, who gathered to play cards or compete in other forms of gambling. To enter the

Timilichee BBQ Club, men applied to take open spots, but a single negative vote from an existing member doomed their prospects. "Nowadays," explains member Junior Brown, "you've got to be one tough bird not to get in." Under current rules, it takes three negative votes to obstruct someone's membership application to this particular club, which rarely occurs. Now, it consists of twenty-four families, who can bring guests to the monthly barbecues.[366]

The Sumterville BBQ Club, which did not start until 2001, does not have any membership requirements. Its founding members started the club to allow people greater access to club meetings, so they did not have to travel to distant events. According to one member, "We are just a community. You can't tell who is Baptist or Presbyterian. We just wanted to have a barbecue club because we wanted to have a community-wide family gathering."[367]

Some clubs continue to have membership requirements. With regard to the requirements of the Emelle Club, which started in the 1950s, member Lolita Smith explains, "You have to either live in Emelle, have grown up in Emelle or own property here. We wanted to keep it in the community."[368]

Recently, barbecue clubs have become more inclusive, but certain traditions sometimes dictate people's roles within the clubs. In the Emelle BBQ Club, women prepare the Emelle Community Center for the meal while men cook, cut and serve the food. At Boyd BBQ Club meetings, men serve themselves in a line formed on the right side of the table while women and children make their way down the line on the left side of the table. According to a member of the Boyd Club, "That is how we have always done it. It's just our tradition."[369]

Over two hundred years, Alabama barbecue has changed, but its essence remains the same, especially in West Alabama. In this part of the state, the barbecue clubs reinvigorate the traditions of old-time barbecue, which facilitate community interaction and raise funds for community needs. According to historian Valerie Pope Burnes, "Barbecue not only feeds the body, it sustains the soul of these rural communities."[370]

NOTES

Chapter 1

1. Geiling, "Evolution of American Barbecue"; Warnes, *Savage Barbecue*, 12–49; Moss, *Barbecue*, 9–11.
2. Warnes, *Savage Barbecue*, 37–42; Moss, *Barbecue*, 11–13.
3. Warnes, *Savage Barbecue*, 35–46.
4. Ibid., 17–18, 174; Rochefort, *History of the Caribby-Islands*, 297–98.
5. Warnes, *Savage Barbecue*, 17–18; Deutsch and Elias, *Barbecue*, 13–24; Moss, *Barbecue*, 5–6, 12.
6. Warnes, *Savage Barbecue*, 13, 17; Kurlansky, *Basque History of the World*, "Postscript: The Death of a Basque Pig."
7. Moss, *Barbecue*, 11–13; Warnes, *Savage Barbecue*, 62.
8. Deutsch and Elias, *Barbecue*, 21–24.
9. Moss, *Barbecue*, 64–65; Anne Yentsch, "Excavating the South," 70; Moore, *History of Alabama*, 451.
10. Moss, *Barbecue*, 11–13; Fischer, *Albion's Seed*, 353–54.
11. Isaac, *Transformation of Virginia*, 88–114.
12. Moss, *Barbecue*, 17; Washington to Wood, July 28, 1758, quoted in Beeman, "Deference," 401–30.
13. Isaac, *Transformation of Virginia*, 110–14; Moss, *Barbecue*, 16–17.
14. Moss, *Barbecue*, 13–17; Beeman, "Deference," 401–30.
15. Rothman, *Slave Country*, 125–27, 173, 183, 218.
16. Moss, *Barbecue*, 24; Howe, *What Hath God Wrought*, 125–27, 137–40.
17. White, *Saint of the Southern Church*, 85–86.

18. Ibid.
19. Waldstreicher, *In the Midst of Perpetual Fetes*; Moss, *Barbecue*, 30–33.
20. Moss, *Barbecue*, 25–34; Waldstreicher, *In the Midst of Perpetual Fetes*.
21. Wood, *Radicalism of the American Revolution*.
22. Warnes, *Savage Barbecue*, 35–46, 49, 53–55, 160–72.
23. Wood, *Radicalism of the American Revolution*.
24. Warnes, *Savage Barbecue*, 35–46, 49, 53–55, 160–72.
25. White, *Saint of the Southern Church*, 90.
26. Ward, "Building of the State," 68.
27. Ad, *Southern Advocate*, July 27, 1827, 1.
28. Ibid.
29. Moss, *Barbecue*, 24–30.
30. DuBose, *Life and Times of William Lowndes Yancey*, 91; Moss, *Barbecue*, 24–30.
31. Cruikshank, *History of Birmingham*, 183.
32. Rothman, *Slave Country*, 173–75; Thornton, *Politics and Power*.

Chapter 2

33. Howe, *What Hath God Wrought*.
34. Dupre, "Barbecues and Pledges," 485–86.
35. Thornton, *Politics and Power*, 6–7; Betts, *Early History of Huntsville*, 3–4.
36. Betts, *Early History of Huntsville*, 22–23.
37. Thornton, *Politics and Power*, 6–7; Betts, *Early History of Huntsville*, 3–4, 22–23.
38. Gilmer, *Sketches*, 6; Thornton, *Politics and Power*, 7–8.
39. Betts, *Early History of Huntsville*, 22–23.
40. Mary Jane McDaniel, "Hugh McVay," *Encyclopedia of Alabama*, accessed July 5, 2016, www.encyclopediaofalabama.org/article/h-1462; Harriet E. Amos Doss, "Gabriel Moore," *Encyclopedia of Alabama*, accessed July 6, 2016, www.encyclopediaofalabama.org/article/h-2004.
41. Thornton, *Politics and Power*, 8–12.
42. Ibid., 12.
43. Ibid.
44. Moss, *Barbecue*, 64–65; Yentsch, "Excavating the South," 70; Moore, *History of Alabama*, 451.
45. Ad, *Southern Advocate*, July 20, 1827, 1.
46. Ibid.
47. *Southern Advocate*, "The Barbacue," July 13, 1827, 3.

48. Ibid., "The Barbacues," April 25, 1828, 3.

49. Ibid., "The Barbacue," July 13, 1827, 3.

50. Ibid., "The Barbacues," April 25, 1828, 3.

51. *Republican Banner*, "Bloody Affair in Alabama," July 28, 1843, 2.

52. Moss, *Barbecue*, 32–33.

53. *Southern Advocate*, "The Barbacue," July 13, 1827, 3.

54. Ibid.

55. Moss, *Barbecue*, 54–55.

56. Ibid., 49, 63; Opie, *Hog and Hominy*, 17–30.

57. *Southern Advocate*, "The Election," August 10, 1827, 3.

58. Ibid.; Dupre, "Barbecues and Pledges," 479–85.

59. *Southern Advocate*, "The Election," August 10, 1827, 3.

60. Ibid., "The Barbacues," April 25, 1828, 3.

61. Ibid., "The Barbacue," July 13, 1827, 3.

62. Ibid.

63. Ibid.

64. Ibid., "The Barbacues," April 25, 1828, 3.

65. Ibid.

66. Ibid., "The Barbacue," July 13, 1827, 3.

67. Ibid.; Moss, *Barbecue*, 54–55; Dupre, "Barbecues and Pledges," 479–85.

68. *Southern Advocate*, "The Barbacue," July 13, 1827, 3.

69. Moss, *Barbecue*, 40–41, 54–55.

Chapter 3

70. Faust, *This Republic of Suffering*, xi–xii; Foner, *Reconstruction*, 1–5, 251–61, 422.

71. Janney, *Remembering the Civil War*.

72. Hodgson, *Cradle of the Confederacy*, 394.

73. *Republican Banner*, "The Union Demonstration at Huntsville," August 16, 1860, 2; Janney, *Remembering the Civil War*, 16; Foner, *Reconstruction*, 45.

74. Moss, *Barbecue*, 2, 20–34, 55–58, 74–80.

75. United States Congress, "John Tyler Morgan," *Biographical Directory of the United States Congress*. I am also indebted to Bobby Joe Seales for his work on Alabama history and for providing information concerning Napoleon B. Mardis.

76. Writers' Program, *Alabama*, 280

77. Ibid.; *Shelby News*, Obituary, October 20, 1892.

78. *Testimony Taken by the Joint Select Committee*, 314–316.
79. Ibid., 246.
80. *Moulton Advertiser*, March 20, 1868; *Moulton Advertiser*, March 27, 1868; *Moulton Advertiser*, August 7, 1868; Horton, "Submitting to the 'Shadow of Slavery,'" 135; Moss, *Barbecue*, 100–2.
81. *Testimony Taken by the Joint Select Committee*, 337.
82. Crook, "Barbour County Background," 250.
83. *Daily American*, "The Latest Outrage: How the Whites of North Alabama Treat the Colored Democrats," September 7, 1876, 4.
84. Horton, "Submitting to the 'Shadow of Slavery,'" 135; Moss, *Barbecue*, 100–2.
85. *Atlanta Constitution*, "Alabama's Campaign Will Be Opened on the 8th of July," July 2, 1890, 4.
86. Ibid., "The Alabama Campaign," July 9, 1890, 1.
87. *Washington Post*, "Political Riot in Alabama," July 28, 1890, 1.
88. *Atlanta Constitution*, "Barbecue in Alabama," July 5, 1896, 12.
89. *Nashville American*, "Campaign Opened," August 13, 1899, 6.
90. Hahn, *Nation Under Our Feet*.
91. Newstelle, "Negro Business League," 43.
92. Wallach, "Dethroning the Deceitful Pork Chop," 165–80.
93. Moss, *Barbecue*, 125.
94. *New York Times*, "Barbarism in Alabama," August 14, 1880, 5.
95. *Daily Constitution*, "In Alabama," July 5, 1879, 1.
96. *Atlanta Constitution*, "Veterans at Oak Bowery," September 1, 1899.
97. Thompson, *History of Barbour County*, 415; Moss, *Barbecue*, 107.
98. *Confederate Veteran* 13, "Confederate Monument at Eufaula, Ala.," January 1905, 13.
99. *New York Times*, "Cotton Hurt by Rust: But the End of the Rainy Season Gives It a Chance to Improve," August 15, 1891, 5.
100. *Daily American*, "A Big Barbecue Year," August 22, 1891, 6.
101. Ibid.

Chapter 4

102. Moss, *Barbecue*, 126–33.
103. Ibid.
104. Ibid.; Cooley, *To Live and Dine in Dixie*, 17–18, 43–44.
105. Moss, *Barbecue*, 126–33.

106. Ibid.
107. James and Bennett, *Story of Coal and Iron*, 161–65.
108. Matsos, interview by Evans.
109. Ibid.
110. Derzis, interview by Johnson.
111. Matsos, interview by Evans; Brown, *Birmingham Food*, 59.
112. Matsos, interview by Evans.
113. Ibid.
114. Ibid.
115. Ibid.
116. Ibid.
117. Ibid.
118. Ibid.
119. Brown, *Birmingham Food*, 21–22.
120. Ibid., 49–51.
121. Beth Eddings, "Michael's Restaurant," *Homewood Star*, June 1, 2012; Roy L. Williams, "Birmingham Restaurant Operator Michael Matsos Dies at 93," *Birmingham News*, January 13, 2012; Brown, *Birmingham Food*, 69–75.
122. Brown, *Birmingham Food*, 27–29, 56.
123. Ibid., 21–22.
124. Derzis, interview by Johnson.
125. Brown, *Birmingham Food*, 27.
126. Derzis, interview by Johnson.
127. Booker, interview by Johnson.
128. Ibid.
129. Ibid.
130. Matsos, interview by Evans.
131. Derzis, interview by Johnson.
132. Matsos, interview by Evans.
133. Ibid., Booker, interview by Johnson.
134. Matsos, interview by Evans.
135. Ibid.
136. Williams, "Birmingham Restaurant Operator"; Derzis, interview by Johnson.
137. Williams, "Birmingham Restaurant Operator."
138. McLemore, interview by Evans.
139. Ibid.
140. Ibid.
141. Ibid.

142. Lilly, interview by Johnson.
143. McLemore, interview by Evans.
144. Ibid.
145. Ibid.
146. Lilly, interview by Johnson.
147. Ibid.
148. Ibid.
149. Ibid.
150. Ibid.
151. Ibid.
152. Ibid.
153. Ibid.
154. Kansas City Barbeque Society, "2016 Rules and Regulations," accessed February 1, 2017, www.kcbs.us/pdf/2016_rules.pdf.
155. Lilly, interview by Johnson.
156. Ibid.
157. Ibid.
158. Ibid.
159. Ibid.

Chapter 5

160. Sugrue, *Origins of the Urban Crisis*.
161. Cooley, *To Live and Dine in Dixie*.
162. Ibid.
163. Opie, *Hog and Hominy*, 101–2. For examples outside the restaurant industry, see R.A. Lawson, *Jim Crow's Counterculture: The Blues and Black Southerners, 1890–1945* (Baton Rouge: Louisiana State University Press, 2010), 18; LeRoi Jones, *Blues People: Negro Music in White America* (New York: William Morrow & Company, 1963), 85; Adam Gussow, *Seems Like Murder Here: Southern Violence and the Blues Tradition* (Chicago: University of Chicago Press, 2002), 6. Psyche A. Williams-Forson analyzes the ways in which black women used chicken to achieve these goals in her book *Building Houses Out of Chicken Legs: Black Women, Food, and Power* (Chapel Hill: University of North Carolina Press, 2006).
164. Moss, *Barbecue*, 150, 213–14.
165. Putzel, *Cases Adjudged in the Supreme Court*, 268–70; Moss, *Barbecue*, 150, 213–14.

166. Don Milazzo, "Ollie's BBQ Closes, but the Sauce Will Live On," *Birmingham Business Journal*, September 23, 2001, www.bizjournals.com/birmingham/stories/2001/09/24/tidbits.html.

167. Williams-Forson, *Building Houses Out of Chicken Legs*.

168. Opie, *Hog and Hominy*, 101–2; Williams-Forson, *Building Houses Out of Chicken Legs*.

169. Jim Shahin, "They Fed the Civil Rights Movement. Now Are Black-Owned Barbecue Joints Dying?" *Washington Post*, February 22, 2016.

170. Ibid.

171. Ibid.

172. Matt Okarmus, "Brenda's Bar-B-Que Pit Winning Flavor Is Family," *Montgomery Advertiser*, September 28, 2015.

173. Ibid.

174. Ibid.

175. Rich Harmon, "Brenda's, Cotton's Enter Ala. Barbecue Hall of Fame," *Montgomery Advertiser*, June 24, 2015.

176. Van Sykes, interview by Mark A. Johnson.

177. Okarmus, "Brenda's Bar-B-Que Pit Winning Flavor Is Family."

178. Shahin, "They Fed the Civil Rights Movement."

179. Hickman, interview by Johnson.

180. *Selma Times-Journal*, "Lannie's Makes Barbecue Hall of Fame," June 24, 2015; Hatcher, interview by Johnson.

181. Hatcher, interview by Johnson.

182. Ibid.

183. Ibid.

184. Hickman, interview by Johnson.

185. Shahin, "They Fed the Civil Rights Movement."

186. Ibid.

187. Hatcher, interview by Johnson.

188. Hickman, interview by Johnson.

189. Hatcher, interview by Johnson.

190. Simon, "Dreamland Barbecue."

191. Ibid.

192. Ibid.

193. Ibid.

194. Chanda Temple, "Dreamland CEO Betsy McAtee's Journey from Retail to Ribs," *Birmingham Magazine*, March 24, 2016, www.al.com/bhammag/index.ssf/2016/03/dreamland_ceo_betsy_mcatees_jo.html.

195. Ibid.

196. Ibid.

197. Ibid.

198. Archibald, interview by Evans.

199. Nancy Lewis, "Archibald's: Another Barbecue Legend Grows Near Tuscaloosa," *Washington Post*, November 28, 1999, G7.

200. Robert Sutton, "Archibald's: Best BBQ," *Tuscaloosa News*, October 31, 2011.

201. Archibald, interview by Evans; Claiborne, Weir and Snow, "Finger Lickin' Good."

202. Sutton, "Archibald's: Best BBQ."

203. Bob Carlton, "The 'Bama Seven Alabama Barbecue Joints Make the Cut," *Birmingham News*, February 25, 2009, 1D.

204. Claiborne, Weir and Snow, "Finger Lickin' Good."

205. Sara Camp Milam, "Celebrate Archibald's Bar-B-Q on November 6," Southern Foodways Alliance, www.southernfoodways.org/celebrate-archibalds-bar-b-q-on-november-6.

206. Lewis, "Archibald's," G7.

207. Pihakis, interview by Johnson.

208. *Tuscaloosa News*, "Born for Barbecue," September 4, 2011.

Chapter 6

209. Altschuler and Blumin, *GI Bill*; May, *Homeward Bound*.

210. Ibid.

211. Blas, "Dwight D. Eisenhower National System," 127–42.

212. Hurley, "From Hash House to Family Restaurant," 1282–308; Moss, *Barbecue*, 194–98.

213. Ebony Davis, "Dothan's Dobbs Famous Bar-B-Que Inducted into State Hall of Fame," *Dothan Eagle*, June 23, 2015.

214. McLemore, interview by Evans; Lilly, interview by Johnson.

215. Matsos, interview by Evans.

216. Rick Harmon, "Brenda's, Cotton's Enter Ala. Barbecue Hall of Fame," *Montgomery Advertiser*, June 23, 2015.

217. *Tuscaloosa News*, "Three Local Barbecue Restaurants to Be Honored in Hall of Fame," June 23, 2015.

218. Johnny's Bar-B-Q, "Our Story," accessed February 3, 2017, johnnysbarbq.com/our-story.

219. Laura Gaddy, "The Rocket in Jacksonville: Still a Blast from the Past," *Anniston Star*, August 10, 2014.

220. Herbert J. Lewis, "Birmingham," *Encyclopedia of Alabama*, accessed February 6, 2017, www.encyclopediaofalabama.org/article/h-1421.

221. Ibid.

222. Carlile's Restaurant, "Our History," accessed February 2, 2016, www.carliles.net/History1.htm.

223. Carlile's Barbecue, "Our Story," accessed February 2, 2016, www.carlilesbbq.com.

224. Ibid., Home Page, accessed February 2, 2016, www.carlilesbbq.com.

225. Carlile's Restaurant, "Our History"; Carlile's Barbecue, "Menu," www.carlilesbbq.com/menu-1.

226. Carlile's Restaurant, "Our History."

227. Michael Seale, "Collat Family Looking to Rebrand, Re-Energize Carlile's BBQ," *Birmingham Business Journal*, May 18, 2016, www.bizjournals.com/birmingham/news/2016/05/16/collat-family-looking-to-rebrand-re-energize.html.

228. Ibid.

229. Richard Headrick, interview by Evans.

230. Susie Headrick, interview by Evans.

231. Ibid.

232. Richard Headrick, interview by Evans.

233. Tony Headrick, interview by Johnson.

234. Susie Headrick, interview by Evans.

235. Richard Headrick, interview by Evans.

236. Tony Headrick, interview by Johnson.

237. Richard Headrick, interview by Evans.

238. Tony Headrick, interview by Johnson; Richard Headrick, interview by Evans, Susie Headrick, interview by Evans.

239. Tony Headrick, interview by Johnson.

240. Ibid.

241. Pettit, interview by Evans.

242. Ibid.

243. Pettit, interview by Johnson.

244. Ibid.

245. Ibid.

246. Ibid.

247. Pettit, interview by Evans.

248. Van Sykes, interview by Johnson.

249. Pettit, interview by Johnson.

250. Ibid.

251. Ibid.

252. Pettit, interview by Evans.

253. Pettit, interview by Johnson.

254. Phillips, interview by Johnson.

255. Pettit, interview by Johnson.

256. Maxine and Van Sykes, interview by Evans.

257. Van Sykes, interview by Johnson.

258. Ibid.

259. Ibid.

260. Ibid.; Maxine and Van Sykes, interview by Evans.

261. Van Sykes, interview by Johnson.

262. Ibid.

263. Ibid.

264. Ibid.

265. Bob Sykes Bar-B-Q, "Menu," accessed March 30, 2016, www.bobsykes.com/index.php?option=com_content&view=article&id=227&Itemid=548.

266. Maxine and Van Sykes, interview by Evans.

267. Nakos, interview by Johnson.

268. Nakos, interview by York.

269. Ibid.

270. Ibid.

271. Nakos, interview by Johnson.

272. Ibid.

273. Nakos, interview by York.

274. Bob Carlton, "Homewood's Demetri's BBQ Makes Playboy's List of 101 Best Breakfasts in America," AL.com, accessed Feb. 2, 2016, www.al.com/entertainment/index.ssf/2014/11/homewoods_demetris_bbq_makes_p.html.

275. Nakos, interview by York.

276. Greg Schmidt, "Huntsville," *Encyclopedia of Alabama*, accessed February 8, 2017, www.encyclopediaofalabama.org/article/h-2498.

277. James P. Kaetz, "Muscle Shoals," *Encyclopedia of Alabama*, accessed February 8, 2017, www.encyclopediaofalabama.org/article/h-3035; Sarah Lawless, "Florence," *Encyclopedia of Alabama*, accessed February 8, 2017, www.encyclopediaofalabama.org/article/h-2121.

278. Thompson, *Alabama Barbecue*, 27; Kornegay, "Mud Creek," 30.

279. Thompson, *Alabama Barbecue*; Kornegay, "Mud Creek," 30.

280. Wes Mayberry, "Caldwell First-Grader," *Daily Sentinel*, November 1, 2014.

281. Thompson, *Alabama Barbecue*, 27; Kornegay, "Mud Creek," 30.

282. Thompson, *Alabama Barbecue*, 27; Kornegay, "Mud Creek," 30.

283. Thompson, *Alabama Barbecue*, 27; Kornegay, "Mud Creek," 30.

284. Bill Campbell, "Initial BBQ Hall of Fame Lists 3 from Shoals," *Times Daily*, June 24, 2015.

285. Thompson, *Alabama Barbecue*, 21.

286. Flo2Go, "Dick Howell's BBQ," accessed February 1, 2017, www.flo2go.net/r/141/restaurants/delivery/Barbeque/Dick-Howells-BBQ-Florence.

287. Bobby Bozeman, "Year of Alabama BBQ Kicks Off; Press Conference in Shoals Announces Tourism Campaign Locally," *Times Daily*, March 3, 2015.

288. Thompson, *Alabama Barbecue*, 35.

289. Old Greenbrier Restaurant, "About Us," accessed February 5, 2017, www.oldgreenbrier.com/aboutus.

290. Lewallen, interview by Johnson; Thompson, *Alabama Barbecue*, 35.

291 *Decatur Daily*, obituary of Martin Westmoreland "Buddy" Evans, October 7, 2011; Bayne Hughes, "Brothers Work Hard to Keep Hometown Feel at Greenbrier," *Decatur Daily*, March 30, 2014.

292 Lewallen, interview by Johnson.

293. Thompson, *Alabama Barbecue*, 35.

294. Catherine Awasthi, "Rick Singleton Wins Lauderdale County Sheriff's Race," *WHNT News*, accessed February 2, 2017, whnt.com/2014/11/04/rick-singleton-wins-lauderdale-county-sheriff; Alabama Republican Party, "Rising Republican Star Rick Singleton," accessed February 3, 2017, algop.org/rising-republican-star-rick-singleton.

295. Ball, interview by Johnson.

296. Campbell, "Initial BBQ Hall of Fame Lists 3 from Shoals."

297. Carter Watkins, "Florence Barbecue Restaurant, Singleton's, Closes Its Doors after 58 Years of Service," *WHNT News*, accessed February 9, 2017, whnt.com/2015/04/30/florence-barbecue-restaurant-singletons-closes-its-doors-after-58-years-of-service.

298. Campbell, "Initial BBQ Hall of Fame Lists 3 from Shoals."

299. Ibid.; Thompson, *Alabama Barbecue*, 36.

300. Campbell, "Initial BBQ Hall of Fame Lists 3 from Shoals."

301. Thompson, *Alabama Barbecue*, 36.
302. Ibid.
303. Ibid.
304. Whitt's Barbecue, "History," accessed February 3, 2017, www.whitts3. com/Content/2/Summary.aspx.
305. Ibid.
306. Tiffeny Owens, "Still Smokin'," *Decatur Daily*, February 29, 2012.
307. Black, "Pit Master's Welcome."
308. Owens, "Still Smokin'."
309. Ibid.
310. Lee Sentell, "Foreword," Thompson, *Alabama Barbecue*, 5.
311. Ibid.

Chapter 7

312. Oosterveer and Sonnenfeld, *Food, Globalization and Sustainability*, 1–3.
313. Ibid.
314. Dimitri and Oberholtzer, "Marketing U.S. Organic Foods," i–iv.
315. Jeannette Beranger, "Heritage Breeds: Why They're Important," *Mother Earth News*, April 1, 2016, 28–33.
316. *Travel & Tourism Market Research Handbook*, "Culinary Tourism," January 1, 2014, 260–66.
317. Brown, *Birmingham Food*, 55, 63.
318. Ibid; Pihakis, interview by Johnson.
319. Pihakis, interview by Johnson.
320. Ibid.; Jim 'n Nick's Community Bar-B-Q, "Menu," accessed February 12, 2017, www.jimnnicks.com/menus/greystone/bar-b-q.
321. Jim 'n Nick's Community Bar-B-Q, "Our Locations," accessed February 13, 2017, www.jimnnicks.com/locations.
322. Ibid., "Chef Drew Robinson," accessed February 12, 2017, www. jimnnicks.com.
323. Pihakis, interview by Johnson; Brown, *Birmingham Food*, 64.
324. *Tuscaloosa News*, "Jim 'N Nick's Named State's Best Barbecue Restaurant," April 9, 2013; Pihakis, interview by Johnson; Bob Carlton, "Birmingham, Mountain Brook, Alex City Restaurants and Chefs Among 2015 James Beard Semifinalists," AL.com, February 18, 2015, www. al.com/entertainment/index.ssf/2015/02/birmingham_alex_city_well-repr.html.

NOTES TO PAGES 122–131

Notes to Pages 122–131

325. Pihakis, interview by Johnson.

326. Ibid.

327. Ibid.; FatbackCollective.com, "Our Story," accessed December 2, 2013, www.fatbackcollective.com/our-story.php; Brown, *Birmingham Food*, 65–66.

328. Brown, *Birmingham Food*, 65, 99–108.

329. Fernandez, interview by Johnson.

330. Ibid.

331. Ibid.

332. Ibid.; Patrick Rupinski, "Moe's Returns," *Tuscaloosa News*, January 24, 2010.

333. Fernandez, interview by Johnson.

334. Ibid.

335. Ibid.

336. Ibid.; Rupinski, "Moe's Returns."

337. Fernandez, interview by Johnson.

338. Ibid.

339. Rupinski, "Moe's Returns,.."

340. Fernandez, interview by Johnson.

341. Ibid.

342. Ibid.

343. Ibid.

344. Ibid.

345. Ibid.

346. Wilson, interview by Johnson.

347. Ibid.; Brown, *Birmingham Food*, 66–68.

348. Wilson, interview by Johnson; Brown, *Birmingham Food*, 66–68;

349. Wilson, interview by Johnson; Brown, *Birmingham Food*, 66–68.

350. Wilson, interview by Johnson; Brown, *Birmingham Food*, 66–68.

351. Wilson, interview by Johnson; Brown, *Birmingham Food*, 68.

352. Saw's BBQ, "Saw's Juke Joint, Crestline," accessed February 11, 2017, www.sawsbbq.com/locations/saws-juke-joint.

353. Wilson, interview by Johnson.

354. Ibid.; Saw's BBQ, "Saw's BBQ Homewood Restaurant Menu," accessed February 12, 2017, www.sawsbbq.com/locations/saws-juke-jointhttp://www.sawsbbq.com/menu-category/homewood-restaurant-menu.

355. McRae, interview by Johnson.

356. Wilson, interview by Johnson; Brown, *Birmingham Food*, 68.

Conclusion

357. CNN Eatocracy, "5@5—Drew Robinson on Why Barbecue Matters," accessed February 13, 2017, cnneatocracy.wordpress.com/2011/01/25/55-chefpitmaster-drew-robinson.
358. *Atlanta Constitution*, "Marksmen at a Barbecue: Montgomery's Swell Shooting Club Takes an Outing," May 9, 1895, 2.
359. Ibid., "Alabama Bar Association: Lawyers Have Annual Meeting and Delightful Barbecue," July 2, 1897, 3.
360. Laura J. Axelrod, "Barbecue Clubs Kindle a Savory Rural Tradition," *Birmingham News*, April 18, 2008.
361. McAlpine and Burnes, "Barbecue Clubs of Sumter County," 8–9.
362. Axelrod, "Barbecue Clubs."
363. McAlpine and Burnes, "Barbecue Clubs of Sumter County," 10.
364. Axelrod, "Barbecue Clubs."
365. McAlpine and Burnes, "Barbecue Clubs of Sumter County," 8–11.
366. Axelrod, "Barbecue Clubs."
367. McAlpine and Burnes, "Barbecue Clubs of Sumter County," 8–11.
368. Axelrod, "Barbecue Clubs."
369. Ibid.
370. Burnes, "Life, Death and Barbecue," 29–43.

BIBLIOGRAPHY

Articles and Essays

Beeman, Richard R. "Deference, Republicanism and the Emergence of Popular Politics." *William and Mary Quarterly* 49, no. 3 (July 1992): 401–30.

Black, Troy. "Pit Master's Welcome." In *The Big Book of BBQ: Recipes and Revelations from the Barbecue Belt*, edited by the Editors of *Southern Living*. New York: Time Inc. Books, 2016.

Blas, Elisheva. "The Dwight D. Eisenhower National System of Interstate and Defense Highways: The Road to Success?" *History Teacher* 44, no. 1 (November 2010): 127–42.

Burnes, Valerie Pope. "Life, Death and Barbecue: Food and Community in Sumter County." *Tributaries: Journal of the Alabama Folklife Association* 13 (2011): 29–43.

Crook, Charles M. "The Barbour County Background to the Election of 1872 and Alabama's Duel Legislatures." *Alabama Review* 56, no. 4 (October 2003): 242–77.

"Culinary Tourism." *Travel & Tourism Market Research Handbook*, January 1, 2014.

Dimitri, Carolyn, and Lydia Oberholtzer. "Marketing U.S. Organic Foods: Recent Trends from Farms to Customers." *United States Department of Agriculture*, September 2009.

Dupre, Daniel. "Barbecues and Pledges: Electioneering and the Rise of Democratic Politics in Alabama." *Journal of Southern History* 60, no. 3 (August 1994): 479–512.

Geiling, Natasha. "The Evolution of American Barbecue." *Smithsonian Magazine*, July 18, 2013. www.smithsonianmag.com/arts-culture/the-evolution-of-american-barbecue-13770775.

Horton, Paul. "Submitting to the 'Shadow of Slavery': The Secession Crisis and Civil War in Alabama's Lawrence County." *Civil War History* 44, no. 2 (June 1998): 111–36.

Hurley, Andrew. "From Hash House to Family Restaurant." *Journal of American History* 83, no. 4 (March 1997): 1282–308.

Kornegay, Jennifer. "Mud Creek: Barbecue the Way Grandpa Cooked It." *Alabama Living* 66, no. 5 (May 2013): 30.

McAlpine, Pam, and Valerie Pope Burnes. "The Barbecue Clubs of Sumter County, Alabama." *Alabama Foodways Gathering: Celebrating Food Traditions from Four Regions of Alabama*, November 7, 2009.

Newstelle, George M. "A Negro Business League at Work." *The Southern Workman* 44 (1915): 43–47.

Wallach, Jennifer Jensen. "Dethroning the Deceitful Pork Chop: Food Reform at the Tuskegee Institute." In *Dethroning the Deceitful Pork Chop: Rethinking African American Foodways from Slavery to Obama*, edited by Jennifer Jensen Wallach, 165–80. Fayetteville: University of Arkansas Press, 2015.

Ward, William Columbus. "The Building of the State." In *Transactions of the Alabama Historical Society, 1899–1903*, vol. 3, edited by Thomas McAdory Owen. Montgomery, AL, 1904.

Yentsch, Anne. "Excavating the South's African American Food History." *African Diaspora Archaeology Newsletter* 11, no. 2 (2008).

Books

Altschuler, Glenn C., and Stuart M. Blumin. *The GI Bill: The New Deal for Veterans*. Oxford, UK: Oxford University Press, 2009.

Betts, Edward Chambers. *Early History of Huntsville, Alabama, 1804 to 1870*. Montgomery, AL: Brown Printing Co., 1916.

Brown, Emily. *Birmingham Food: A Magic City Menu*. Charleston, SC: The History Press, 2015.

Cooley, Angela Jill. *To Live and Dine in Dixie: The Evolution of Urban Food Culture in the Jim Crow South*. Athens: University of Georgia Press, 2015.

Cruikshank, George M. *A History of Birmingham and Its Environs: A Narrative Account of Their Historical Progress, Their People, and Their Principal Interests*. Chicago: Lewis Publishing Company, 1920.

Deutsch, Jonathan, and Megan J. Elias. *Barbecue: A Global History*. London: Reaktion Books Ltd., 2014.

DuBose, John Witherspoon. *The Life and Times of William Lowndes Yancey*. Birmingham, AL: Roberts & Son, 1892.

Faust, Drew Gilpin. *This Republic of Suffering: Death and the American Civil War*. New York: Vintage Books, 2008.

Fischer, David Hackett. *Albion's Seed: Four British Folkways in America*. New York: Oxford University Press, 1989.

Foner, Eric. *Reconstruction: America's Unfinished Revolution, 1863–1877*. New York: Perennial Classics, 1988.

Gilmer, George R. *Sketches of Some of the First Settlers of Upper Georgia, of the Cherokees, and the Author*. Baltimore: Genealogical Publishing Company, 1965.

Hahn, Steven. *A Nation Under Our Feet: Black Political Struggles in the Rural South to the Great Migration*. Cambridge, MA: Harvard University Press, 2003.

Hodgson, Joseph. *Cradle of the Confederacy; Or, the Times of Troup, Quitman, and Yancey: A Sketch of Southwestern Political History from the Formation of the Federal Government to A.D. 1861*. Mobile, AL: Register Publishing Office, 1876.

Howe, Daniel Walker. *What Hath God Wrought: The Transformation of America, 1815–1848*. New York: Oxford University Press, 2007.

Isaac, Rhys. *The Transformation of Virginia, 1740–1790*. Chapel Hill: University of North Carolina, 2012.

James, Ethel, and James R. Bennett. *The Story of Coal and Iron in Alabama*. Tuscaloosa: University of Alabama Press, 2011.

Janney, Caroline E. *Remembering the Civil War: Reunion and the Limits of Reconciliation*. Chapel Hill: University of North Carolina Press, 2013.

Kurlansky, Mark. *The Basque History of the World*. Toronto: Vintage Canada, 1999.

May, Elaine Tyler. *Homeward Bound: American Families in the Cold War Era*. New York: Basic Books, 2008.

Moore, Albert Burton. *History of Alabama and Her People*. Chicago: American Historical Society, 1927.

Moss, Robert F. *Barbecue: The History of an American Institution*. Tuscaloosa: University of Alabama Press, 2010.

Oosterveer, Peter, and David A. Sonnenfeld. *Food, Globalization and Sustainability*. New York: Routledge, 2012.

Opie, Frederick Douglass. *Hog and Hominy: Soul Food from Africa to America*. New York: Columbia University Press, 2008.

Putzel, Henry, Jr. *Cases Adjudged in the Supreme Court at October Term, 1964*. Washington, D.C.: United States Government Printing Office, 1965.

Rochefort, César de. *The History of the Caribby-Islands*. Translated by John Davies. London: Thomas Dring and John Starkey, 1666.

Rothman, Adam. *Slave Country: American Expansion and the Origins of the Deep South*. Cambridge, MA: Harvard University Press, 2005.

Sugrue, Thomas. *Origins of the Urban Crisis: Race and Inequality in Postwar Detroit*. Princeton, NJ: Princeton University Press, 2005.

Testimony Taken by the Joint Select Committee to Inquire into the Condition of Affairs in the Late Insurrectionary States. Vol. 1. Washington, D.C.: Government Printing Office, 1872.

Thompson, Annette. *Alabama Barbecue: Delicious Road Trips*. Birmingham: Alabama Media Group, 2014.

Thompson, Mattie Thomas. *History of Barbour County, Alabama*. Eufaula, AL, 1939.

Thornton, J. Mills. *Politics and Power in a Slave Society*. Baton Rouge: Louisiana State University Press, 1978.

Waldstreicher, David. *In the Midst of Perpetual Fetes: The Making of American Nationalism 1776–1820*. Chapel Hill: University of North Carolina Press, 1997.

Warnes, Andrew. *Savage Barbecue: Race, Culture, and the Invention of America's First Food*. Athens: University of Georgia Press, 2008.

White, Greenough. *A Saint of the Southern Church: Memoir of the Right Reverend Nicholas Hamner Cobbs*. New York: Thomas Whittaker, 1900.

Williams-Forson, Psyche A. *Building Houses Out of Chicken Legs: Black Women, Food, and Power*. Chapel Hill: University of North Carolina Press, 2006.

Wood, Gordon S. *The Radicalism of the American Revolution*. New York: Vintage Books, 1991.

Writers' Program of the Works Projects Administration in the State of Alabama. *Alabama: A Guide to the Deep South*. New York: Hastings House, 1949.

Interviews

Archibald, George, Jr. Southern Foodways Alliance. By Amy Evans, October 5, 2006.

Ball, Blake S. By Mark A. Johnson, February 5, 2017.

Booker, Michael. By Mark A. Johnson, September 30, 2016.

Derzis, Sammy. By Mark A. Johnson, September 30, 2016.

Fernandez, Mike. By Mark A. Johnson, April 18, 2016.

Hatcher, Sam. By Mark A. Johnson, May 18, 2016.

Headrick, Richard. Southern Foodways Alliance. By Amy Evans, September 29, 2006.

Headrick, Susie. Southern Foodways Alliance. By Amy Evans, September 29, 2006.

Headrick, Tony. By Mark A. Johnson, May 13, 2016.

Hickman, Caroline. By Mark A. Johnson, May 18, 2016.

Lewallen, Pat. By Mark A. Johnson, February 5, 2017.

Lilly, Chris. By Mark A. Johnson, March 24, 2016.

Matsos, Michael. Southern Foodways Alliance. By Amy Evans, October 3, 2006.

McLemore, Don. Southern Foodways Alliance. By Amy Evans, November 15, 2006.

McRae, David. By Mark A. Johnson, February 11, 2017.

Nakos, Sam. By Mark A. Johnson, May 13, 2016.

———. Southern Foodways Alliance. By Jake York, December 30, 2004.

Pettit, Dale. By Mark A. Johnson, March 24, 2016.

———. Southern Foodways Alliance. By Amy Evans, October 5, 2006.

Phillips, Heather. By Mark A. Johnson, March 25, 2016.

Pihakis, Nick. By Mark A. Johnson, November 27, 2013.

Sykes, Maxine, and Van Sykes. Southern Foodways Alliance. By Amy Evans, September 30, 2006.

Sykes, Van. By Mark A. Johnson May 17, 2016.

Wilson, Mike. By Mark A. Johnson, May 13, 2016.

Newspapers and Magazines

Alabama Living

Anniston Star

Atlanta Constitution

Birmingham Business Journal

Birmingham Magazine

Birmingham News

Confederate Veteran

Daily American (Nashville, TN)

Daily Constitution (Atlanta, GA)

Daily Sentinel (Scottsboro, AL)

Decatur Daily

Dothan Eagle

Homewood Star

Montgomery Advertiser

Mother Earth News

Moulton Advertiser (Moulton, AL)

Nashville American

New York Times

Republican Banner (Nashville, TN)

Selma Times-Journal

Shelby News (Calera, AL)

Southern Advocate (Huntsville, AL)

Times Daily (Florence, AL)

Tuscaloosa News

Washington Post

Radio and Television

Claiborne, Ron, Bill Weir and Kate Snow. "Finger Lickin' Good." *Good Morning America*. Transcript. May 23, 2009. Accessed via Regional Business News Database.

Simon, Scott. "Dreamland Barbecue Grown to Three Almost Four Stores." *Weekend Edition*. National Public Radio. Transcript. September 2, 1995. Accessed via Regional Business News Database.

Reference

Biographical Directory of the United States Congress
Encyclopedia of Alabama

Websites

Alabama Republican Party
AL.com
Bob Sykes Bar-B-Q
Carlile's Barbecue
Carlile's Restaurant
Fatback Collective
Flo2Go
Jim 'n Nick's Community Bar-B-Q
Johnny's Bar-B-Q
Kansas City Barbeque Society
Old Greenbrier Restaurant
Saw's BBQ
Southern Foodways Alliance
Whitt's Barbecue
WHNT News

INDEX

INDEX

M

Madison, AL 50, 110, 114
Madison County, AL 24, 26, 27, 31, 34
Matsos, Michael 48, 49, 50, 51, 53, 54, 55, 88, 120
McClung, James "Ollie" 71
Mobile, AL 26, 44, 78
Moe's Original BBQ 120, 128
Montgomery, AL 37, 41, 42, 43, 72, 73, 74, 76, 89, 133
Mud Creek Fishing Camp Restaurant 113
Muscle Shoals, AL 111, 112, 116

N

Native Americans 12, 13, 14, 15, 17, 85, 126
Northport, AL 81

O

Old Greenbrier Restaurant 115
Ollie's Barbecue 71, 121

P

Panola BBQ Club 134
pigs 17, 31, 74, 111, 123, 126
Pihakis, Nick 120
pork 11, 13, 17, 18, 22, 28, 42, 47, 48, 52, 53, 54, 58, 61, 64, 66, 67, 74, 82, 83, 91, 96, 99, 104, 108, 112, 113, 114, 115, 116, 117, 118, 121, 126, 130, 134

R

Rocket Drive Inn 89

S

Saw's BBQ 120, 128, 129, 131
segregation 49, 70, 71, 77
Southern Foodways Alliance 83, 128
Sumterville BBQ Club 134, 135

T

Tennessee River Valley 11, 24, 89, 110, 111, 112, 115, 118, 121
Timilichee BBQ Club 134
tomato-based sauce 11, 54, 75, 96, 100, 106
Top Hat Barbecue 100
Tuscaloosa, AL 11, 49, 77, 81, 85, 89, 104, 122, 123, 124, 125

V

vinegar-based sauce 11, 82, 91, 112, 118, 121, 126, 130

W

Walker County, AL 41, 93, 95
Washington, Booker T. 41, 42
white sauce 11, 57, 58, 68, 91, 95, 111, 112, 113, 114, 115, 121, 126, 130
Whitt's Barbecue 118
World War II 49, 72, 87, 88, 89, 91, 93, 101, 107, 110, 111

Y

Yancey, AL 39

ABOUT THE AUTHOR

 ark A. Johnson, from Milwaukee, graduated in 2016 with a PhD in history from the University of Alabama. Previously, he earned an MA from the University of Maryland and a BA from Purdue University. As a professional historian, he specializes in the history of the United States and the U.S. South.